CONTENTS

W9-BEL-927

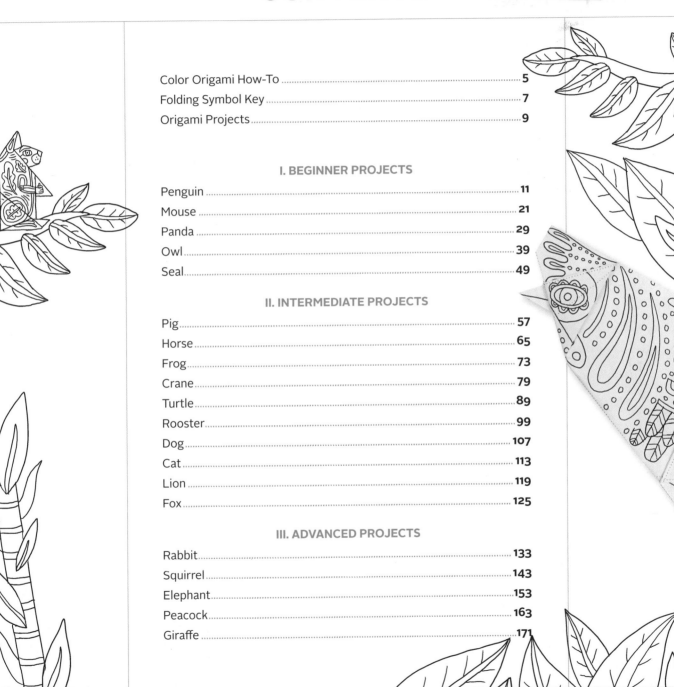

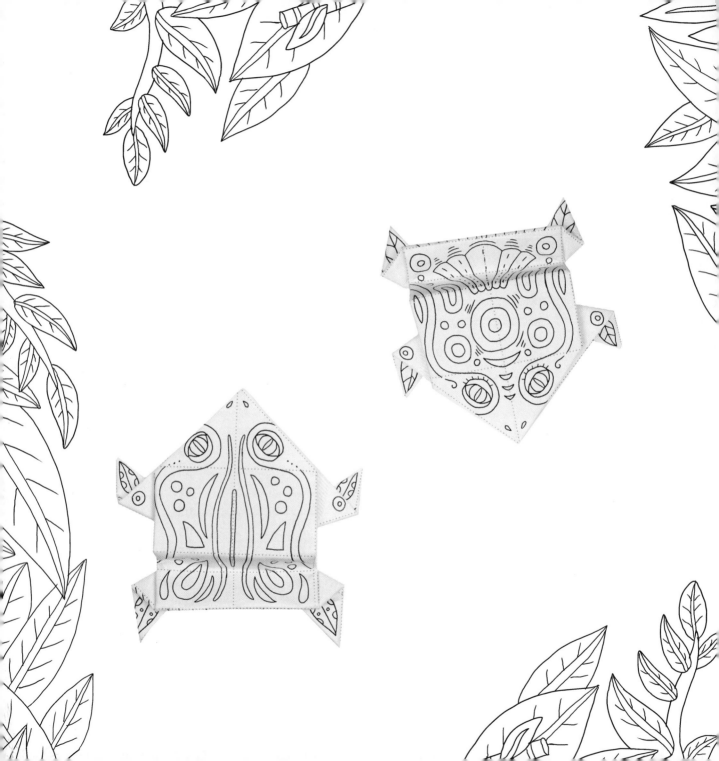

COLOR ORIGAMI HOW-TO

Remove, color, and fold the pages in this book to make an eclectic menagerie of animals. Every project has folding instructions, followed by coloring origami sheets printed with guidelines to make folding easier. If you are a beginner, start with the origami patterns in the front.

A FEW TIPS BEFORE YOU GET STARTED:

1. All projects have instructions followed by at least two coloring sheets. Most have a third or fourth sheet that is a repeat of the designs.

Instructions Design 1 Design 2

2. If you have a specific idea for coloring a project, fold it first to see how the design comes together. Then unfold the sheet, color, and refold it.

FLAT FOLDED

3. Pay close attention to the first step of the instructions that shows how the sheet should look before you begin folding. The sheets are marked "front," "back," and "top." The coloring designs will not align correctly if the sheet is positioned upside-down from the beginning.

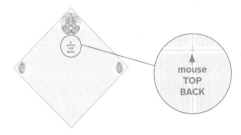

4. Some projects have double-sided designs; check both sides of the sheet before coloring with a marker, which may bleed through the page.

5. Make note of the gray shaded areas of the origami sheet. These areas will not be visible once the sheet is folded, so you don't need to color them in.

Areas printed with the dotted design are semi-visible when the sheet is folded. Coloring these areas is optional.

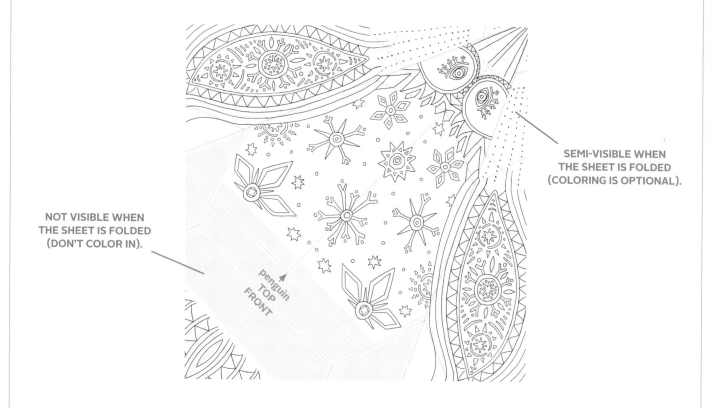

SEMI-VISIBLE WHEN THE SHEET IS FOLDED (COLORING IS OPTIONAL).

NOT VISIBLE WHEN THE SHEET IS FOLDED (DON'T COLOR IN).

penguin TOP FRONT

NOTE: Minor variations in the printing of the origami sheets are to be expected. If you are using a sheet with guidelines that are slightly off-center, follow the instructions and use the dotted folding lines as a general guide.

FOLDING SYMBOL KEY

FOLD

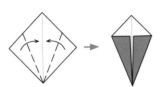

Always fold the sheet in the direction of the arrow.

FOLD BEHIND

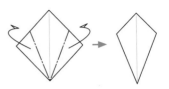

This arrow indicates the sheet is being folded behind the origami model.

PRECREASE

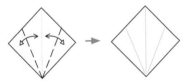

"Precreasing" means folding and unfolding the sheet to make a new crease.

TURN OVER

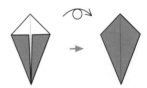

Flip the origami model over before proceeding with the next step.

ROTATE

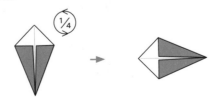

Turn the origami model clockwise or counterclockwise as directed.

FOLDING SYMBOL KEY CONTINUED

REVERSE FOLD:

A reverse fold means changing the direction of a crease.
The affected crease is indicated by a solid triangle.
The direction of the reverse fold is often indicated by an arrow.

HERE ARE TWO EXAMPLES OF REVERSE FOLDS.

BEFORE	IN PROGRESS	AFTER
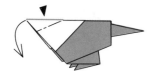	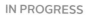 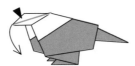	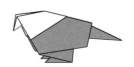
BEFORE	IN PROGRESS	AFTER

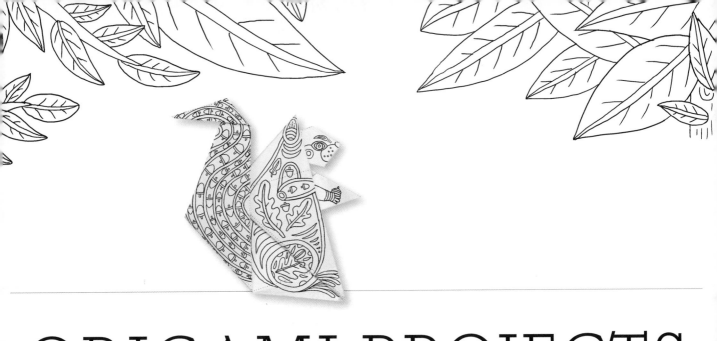

ORIGAMI PROJECTS

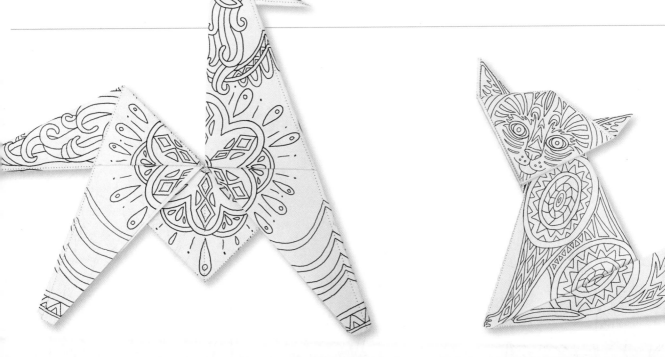

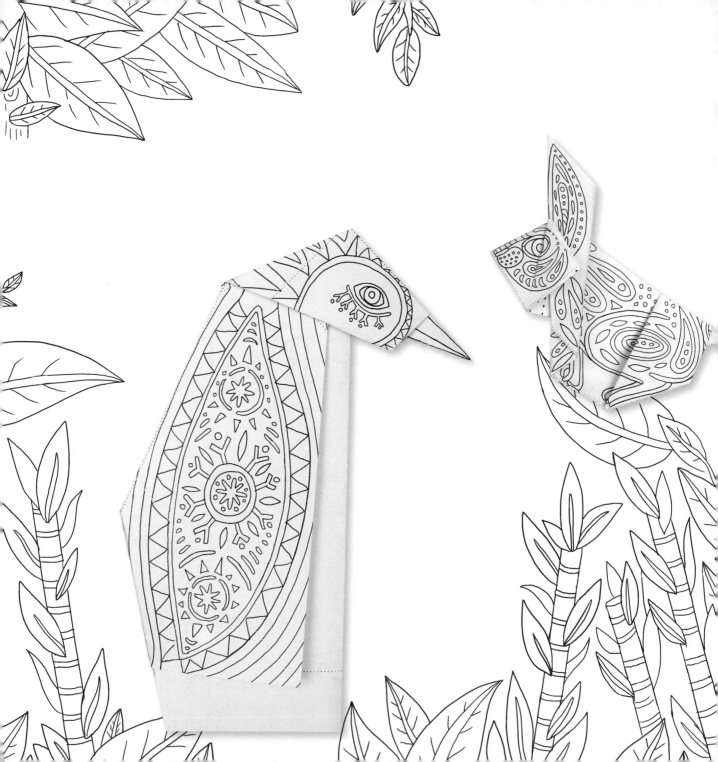

PENGUIN
BEGINNER

1.
Start with the sheet positioned like this (front side up).

2.
Precrease the sheet along the diagonals.

3.
Fold the top corner to the center.

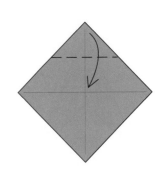

4.
Fold the corner up to the top edge.

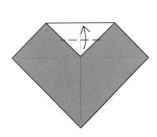

5.
Fold the bottom corner up to meet the dotted point.

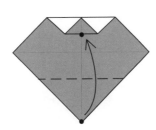

6.
Unfold the top corner.

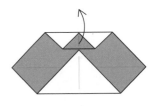

7.
Fold the sides behind on the guidelines.

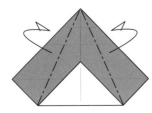

8.
Open out the bottom flap.

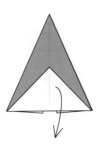

9.
Fold the bottom point up on the indicated guideline.

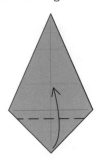

PENGUIN CONTINUED

10.
Fold the corner down to the bottom edge.

11.
Fold the sides in on the guidelines
(dotted points should meet).

12.
Fold the beak down on the top guideline.

13.
Fold the beak behind on the next guideline.
The point will flip upward.

14.
Fold the head behind on the guideline.

15.
Fold in half (right side over left).

16.
Slide the head up and crease
on the guidelines.

17.
Completed Penguin.

penguin
TOP
FRONT

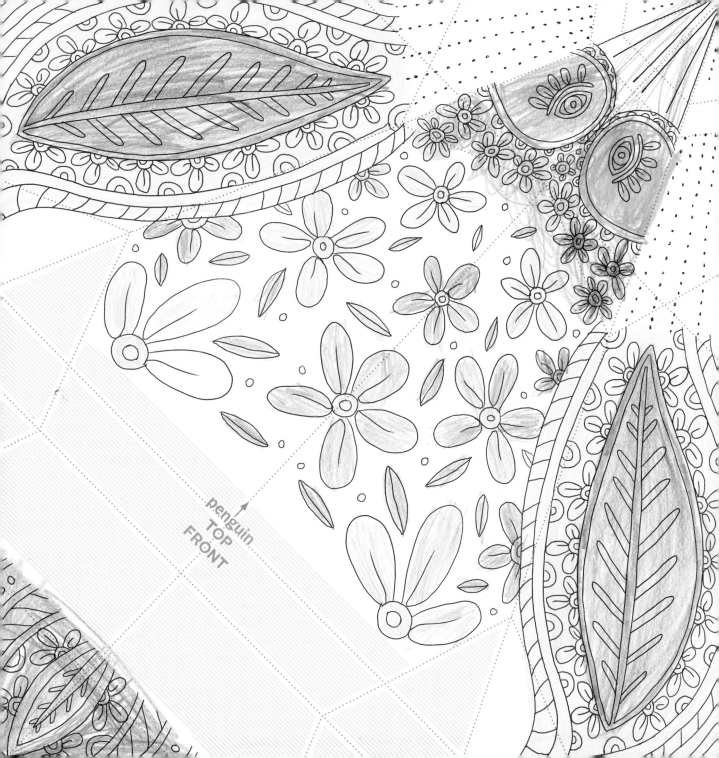

penguin
TOP
FRONT

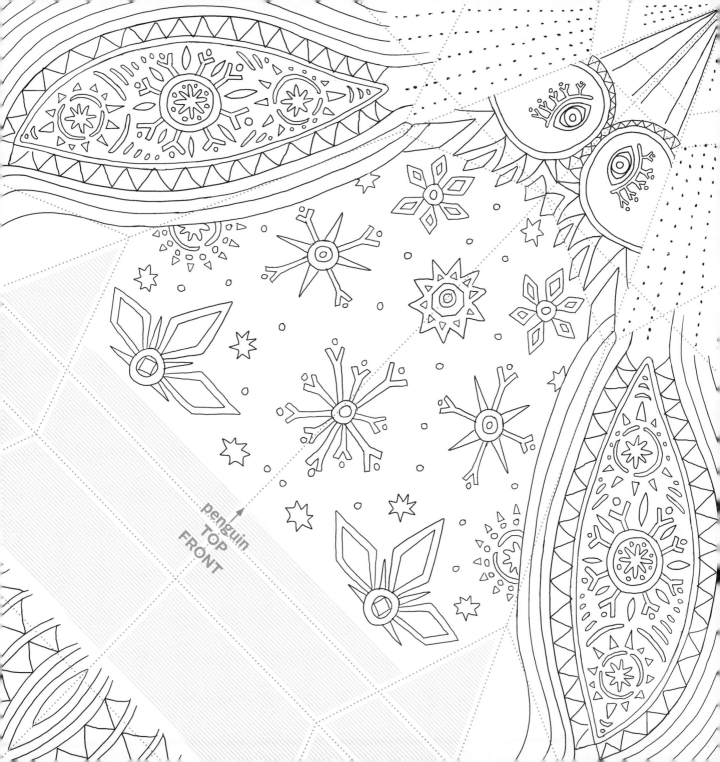

MOUSE
BEGINNER

1.
Start with the sheet positioned like this
(back side up).

2.
Precrease the sheet in half
along the diagonal.

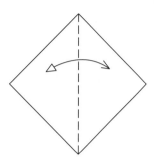

3.
Precrease the sides to the center
on the guidelines.

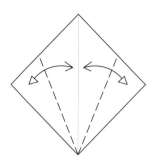

4.
Fold the top corner down on the guideline.

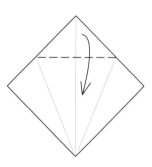

5.
Fold the corner up on the guideline.

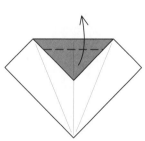

6.
Fold the sides to the center.

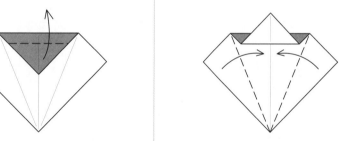

7.
Fold the corners out on the guidelines.

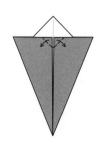

8.
Turn the Mouse over.

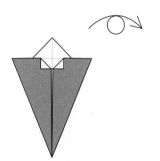

9.
Fold the bottom corner up
to meet the top corner.

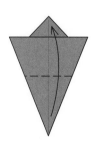

MOUSE CONTINUED

10.
Fold the tail down on the guideline.

11.
Fold the top corner down on the guideline.

12.
Fold the sides in on the guidelines.

13.
Fold the sides out on the guidelines.

14.
Fold the Mouse in half (right side over left) and rotate it a ¼ turn.

15.
Completed Mouse.

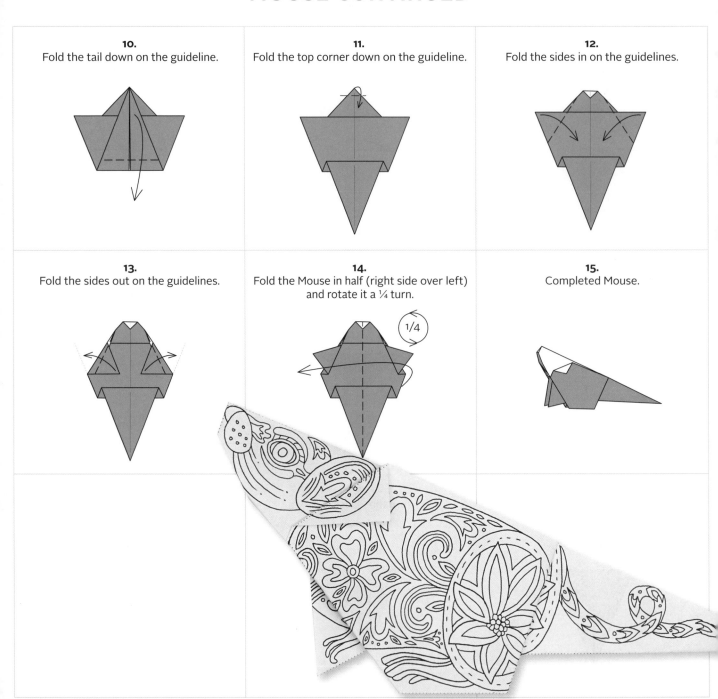

mouse
TOP
BACK

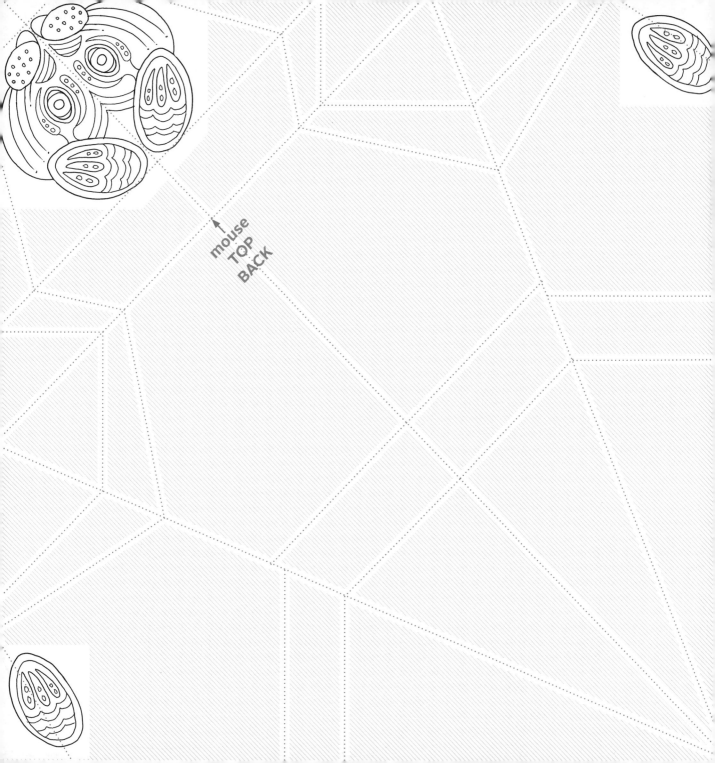

mouse
TOP
BACK

panda
TOP
FRONT

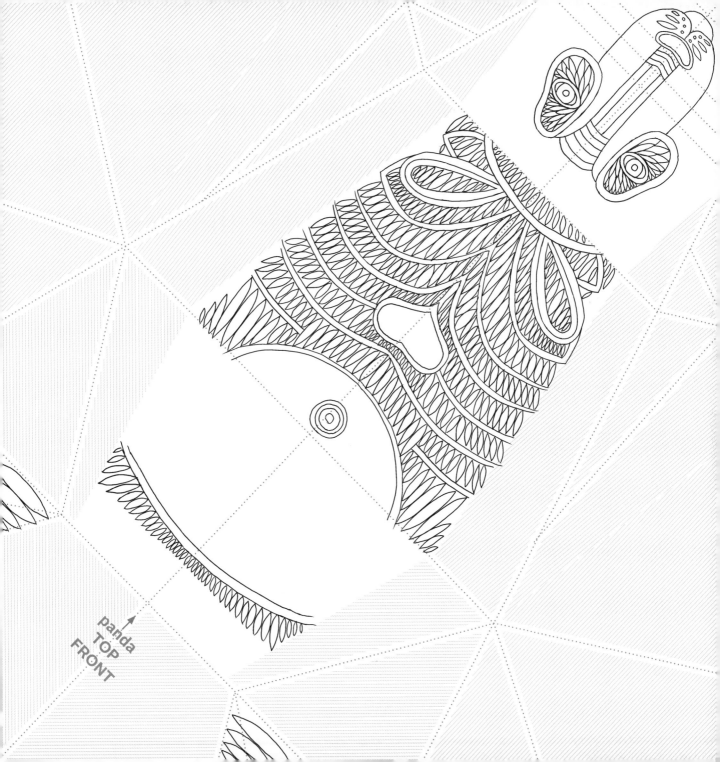

panda
TOP
FRONT

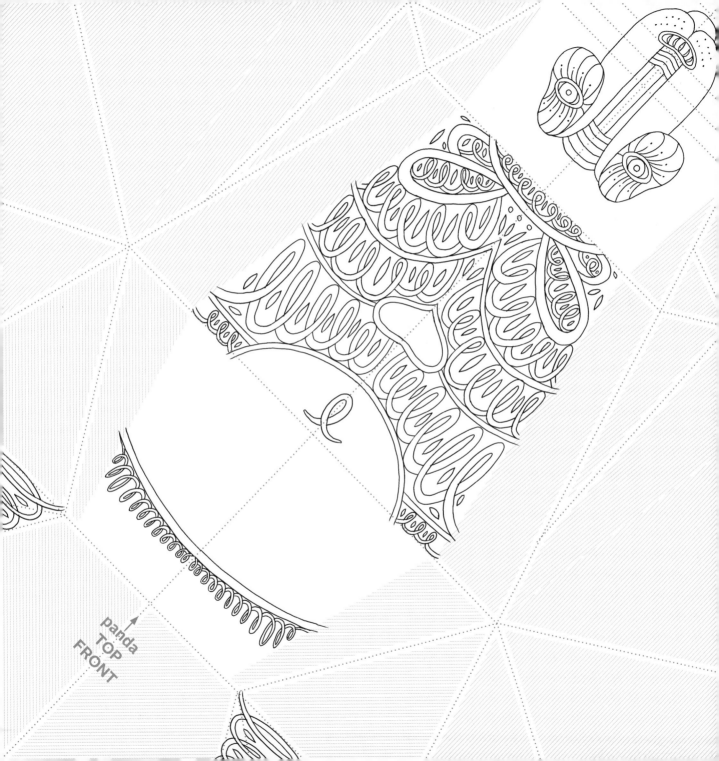

panda
TOP
FRONT

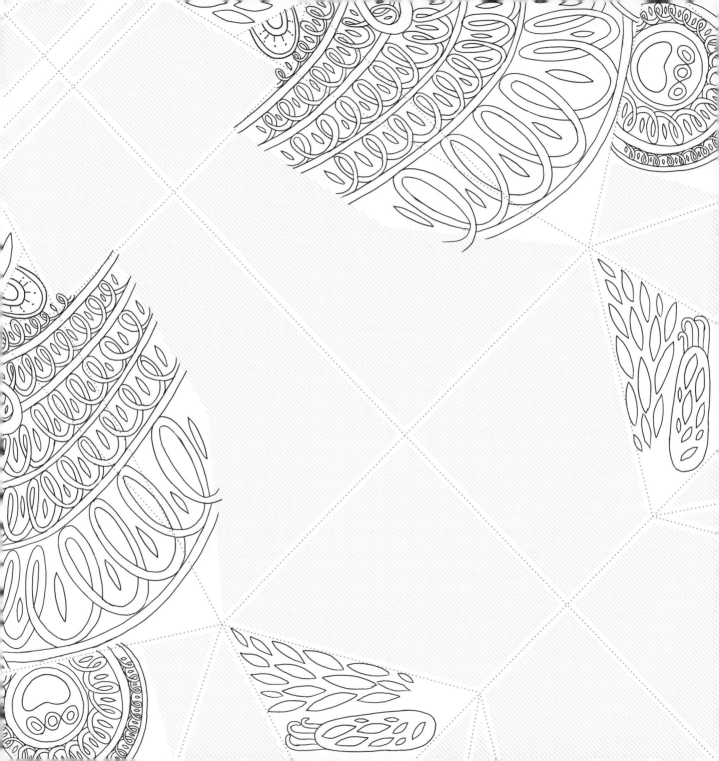

OWL

1.
Start with the sheet positioned like this (back side up).

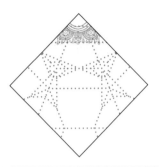

2.
Precrease the sheet along the diagonals.

3.
Fold the top corner behind and the bottom corner up on the guidelines.

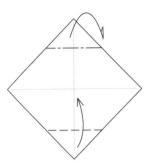

4.
Fold the sides to the center on the guidelines.

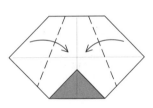

5.
Fold the top of the Owl behind on the guideline.

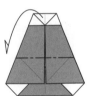

6.
Fold the sides in on the guidelines.

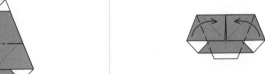

7.
Unfold the head from behind.

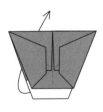

8.
Fold the head down toward the center crease (top corner will flip up).

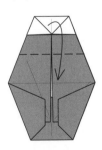

9.
Fold the beak down on the guideline.

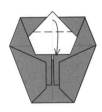

10.
Turn the Owl over.

11.
Fold the sides in on the guidelines.

12.
Fold the ears down on the guidelines.

13.
Fold the ears up on the guidelines.

14.
Turn the Owl over.

15.
Completed Owl.

owl
TOP
BACK

owl
TOP
BACK

owl
TOP
BACK

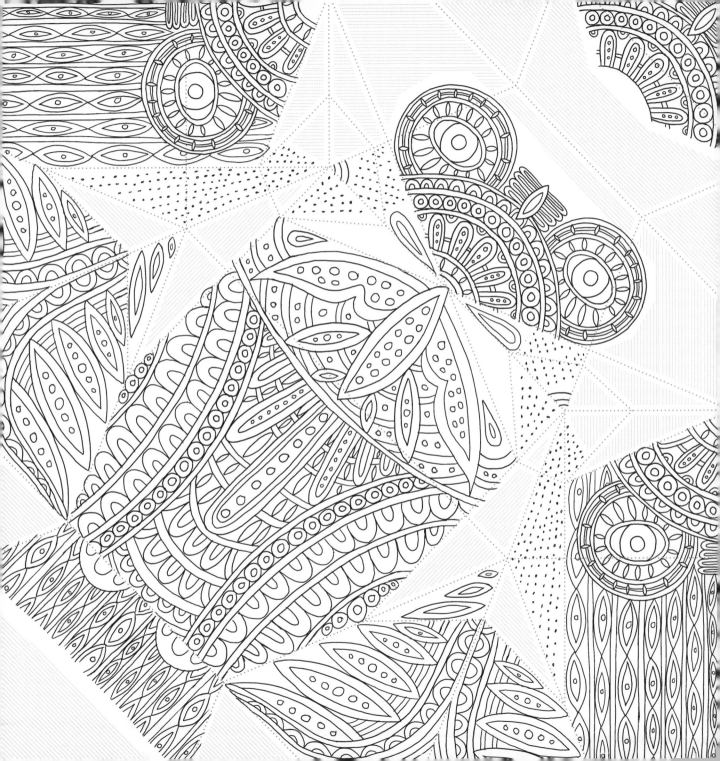

owl
TOP
BACK

SEAL
BEGINNER

1.
Start with the sheet positioned like this (back side up).

2.
Precrease the sheet along the diagonals.

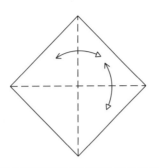

3.
Precrease the sides to the center.

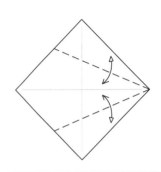

4.
Fold the sides to the center.

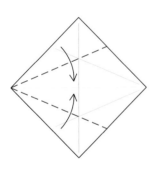

5.
Fold the left corner behind to meet the right corner on the guideline.

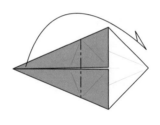

6.
Pull the two flaps out, allowing the sides to fold to the center and press flat.

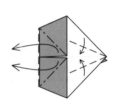

7.
Fold the top flap over to the left.

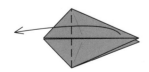

8.
Fold in half (bottom over top).

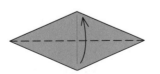

9.
Reverse fold the head straight up.

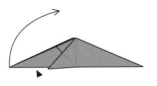

SEAL CONTINUED

10.
Reverse fold the head out on the guidelines.

11.
Reverse fold the point of the head in on the guidelines.

12.
Fold the flippers behind on the guidelines and reverse fold the tail up.

13.
Fold the flippers up so that the Seal can rest upright on them.

14.
Completed Seal.

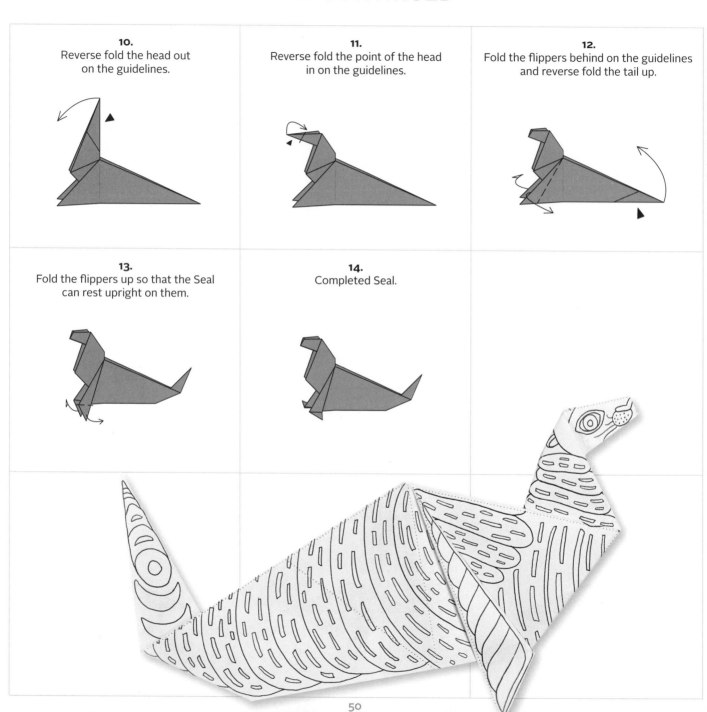

seal
TOP
BACK

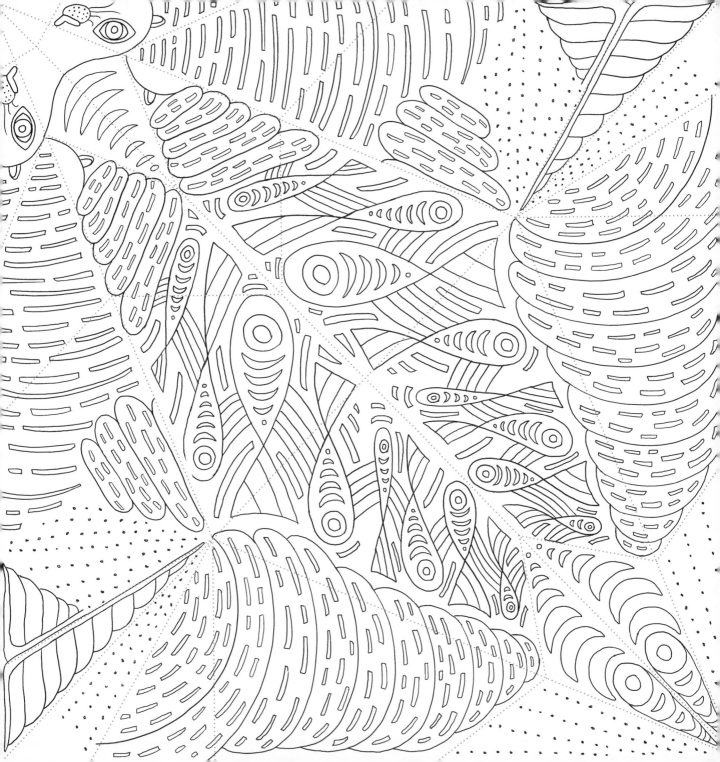

PIG
INTERMEDIATE

1.
Start with the sheet positioned like this (back side up).

2.
Precrease the sheet along the diagonals.

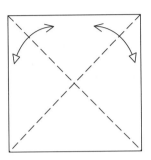

3.
Precrease the sheet in half.

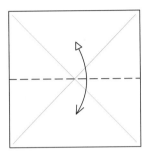

4.
Fold the top and bottom to the center.

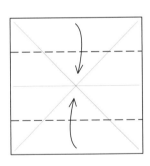

5.
Reverse fold the four corners on the left and right sides as shown.

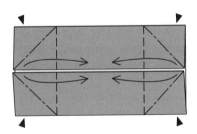

6.
Fold the bottom half behind the top.

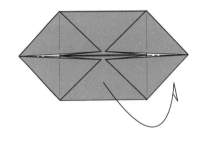

7.
Fold the four leg flaps down on the guidelines.

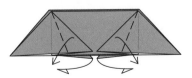

8.
Reverse fold the snout in on the guideline.

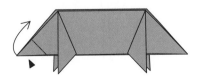

9.
Reverse fold the tail in on the guideline.

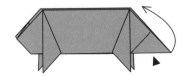

10.
Reverse fold the tip of the tail out at the guideline.

11.
Completed Pig.

Tip: Coloring the Pig with markers is faster than using colored pencils, and you don't need to worry about bleed-through (the entire design is printed on one side of the sheet).

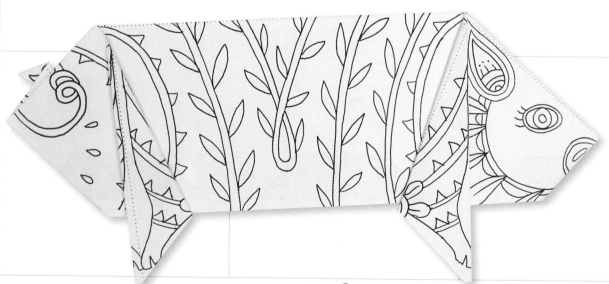

pig
TOP
BACK

pig
TOP
BACK

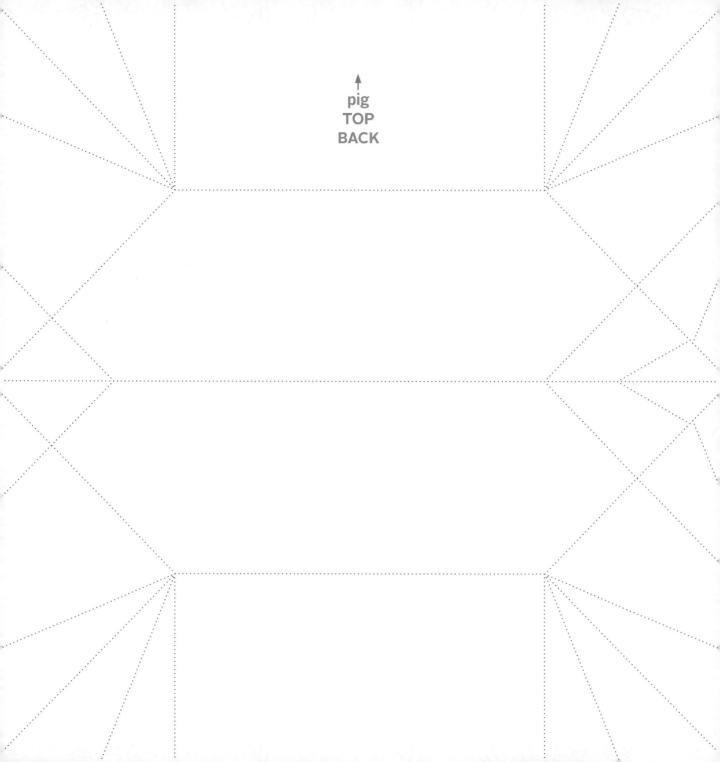

pig
TOP
BACK

HORSE
INTERMEDIATE

1.
Start with the sheet positioned like this
(front side up).

2.
Precrease the sheet along the diagonals.
Turn the sheet over.

3.
Precrease the sheet in half
in both directions.

4.
Bring the dotted points to the top point,
using the creases formed in Steps 2 and 3.

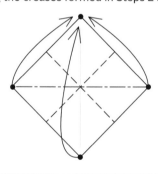

5.
Step 4 in progress.

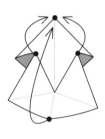

6.
Fold the sides to the center
on the guidelines.

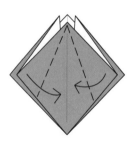

7.
Fold the bottom corner behind.

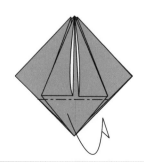

8.
Open out the sides and bottom.

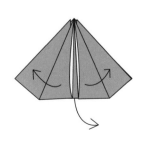

9.
Cut the top layer on the orange dotted line.

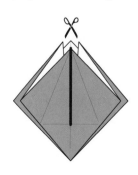

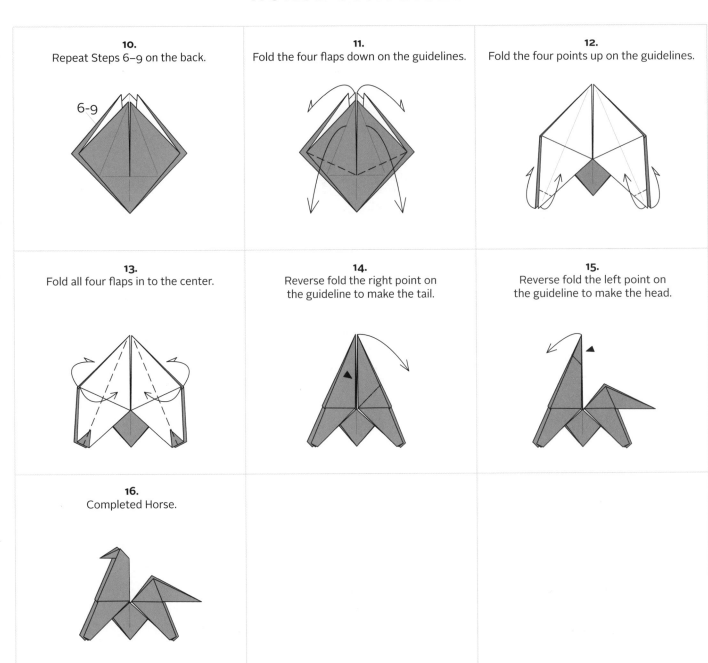

10.
Repeat Steps 6–9 on the back.

6-9

11.
Fold the four flaps down on the guidelines.

12.
Fold the four points up on the guidelines.

13.
Fold all four flaps in to the center.

14.
Reverse fold the right point on the guideline to make the tail.

15.
Reverse fold the left point on the guideline to make the head.

16.
Completed Horse.

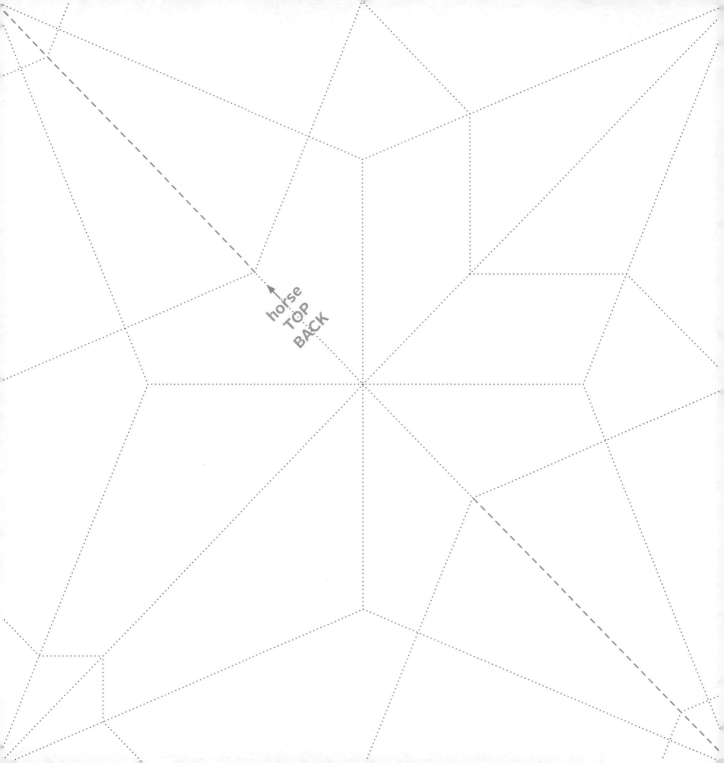

horse
TOP
BACK

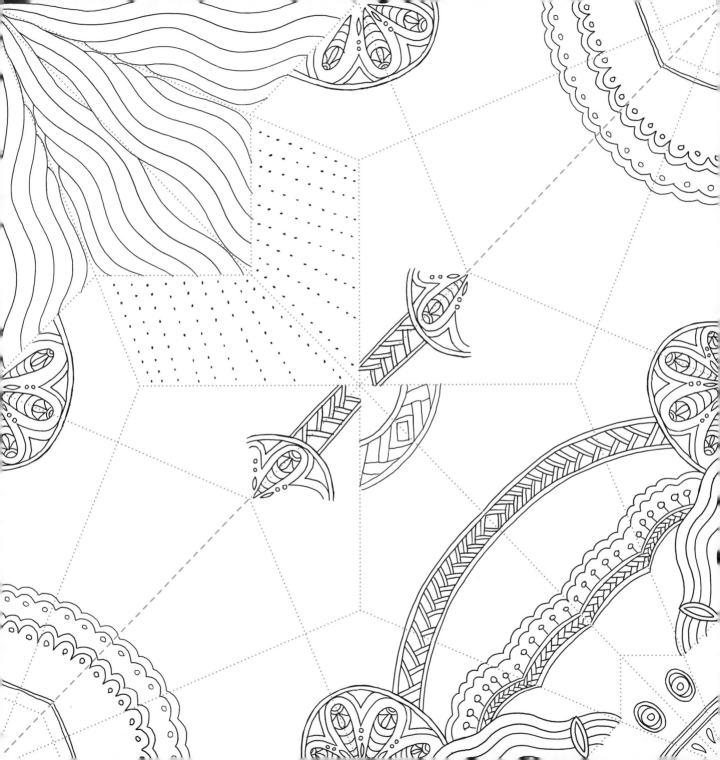

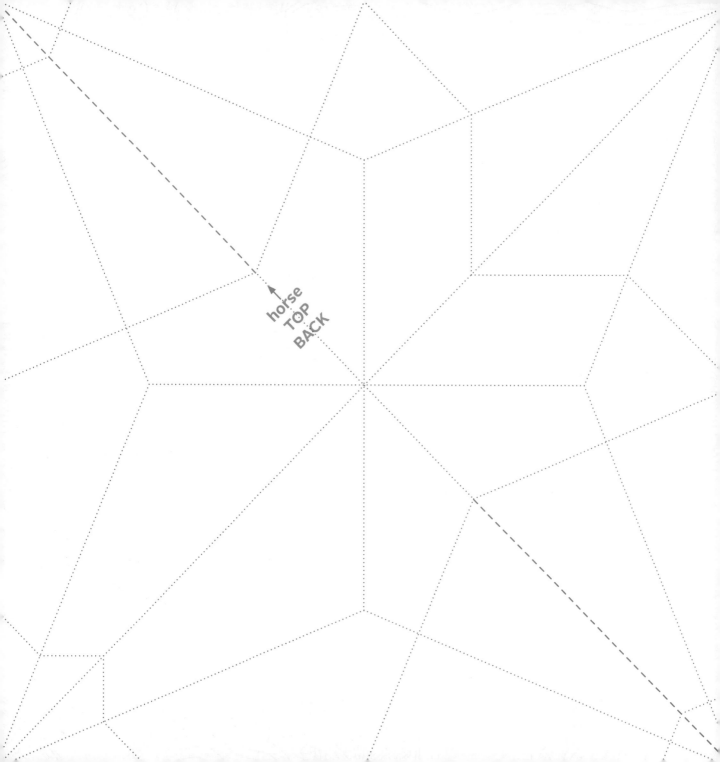

horse
TOP
BACK

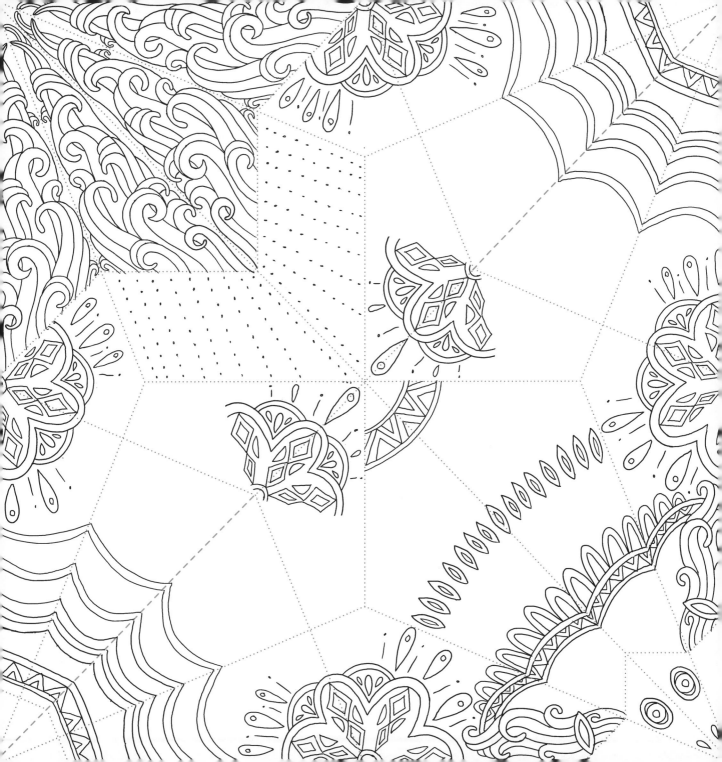

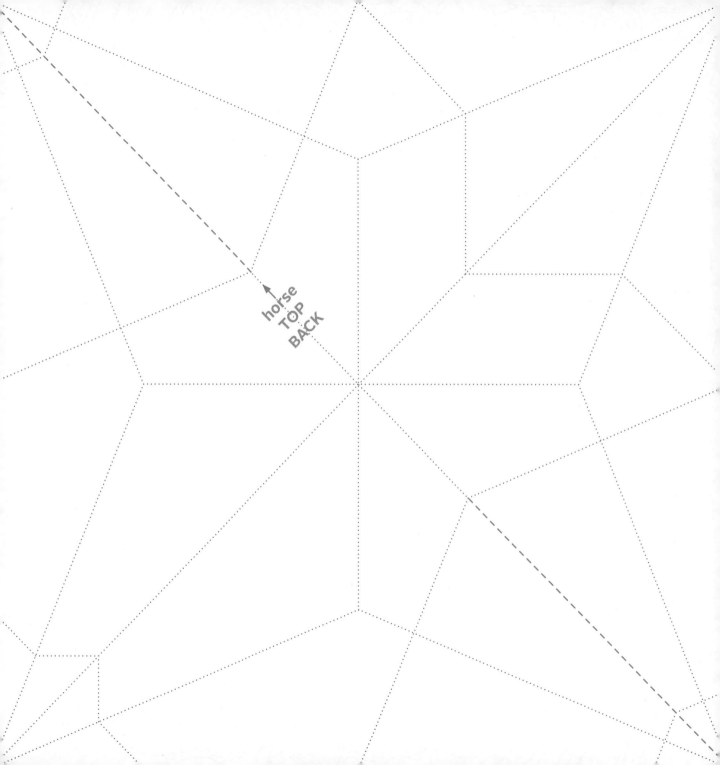

horse
TOP
BACK

FROG

INTERMEDIATE

1.
Begin with the sheet positioned like this (back side up).

2.
Cut the sheet in half on the orange dashed guideline. Put one half aside.

3.
Precrease the corners in half on the guidelines.

4.
Precrease the sheet where the diagonals meet, on the guideline.

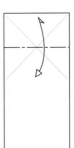

5.
Reverse fold the sides inward while bringing the top edge down.

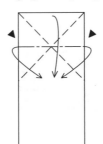

6.
Fold the bottom edge up on the guideline.

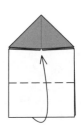

7.
Fold the flaps up on the guidelines.

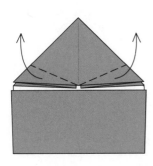

8.
Fold the sides to the center under the flaps on the guidelines.

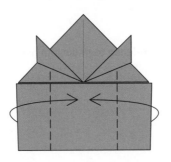

9.
Fold the bottom edge up on the guideline.

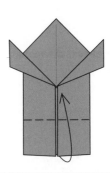

FROG CONTINUED

10.
Fold the corners down on the guidelines.

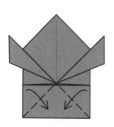

11.
Pull out the indicated corners and flatten.

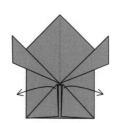

12.
Fold the flaps down on the guidelines.

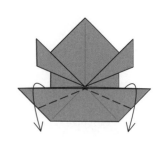

13.
Pleat the body on the guidelines.

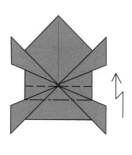

14.
Turn the Frog over.

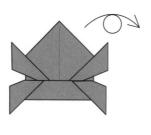

15.
Completed Frog.

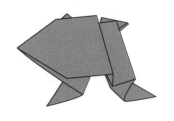

Tip: Press down on the Frog's back legs and release to make him hop.

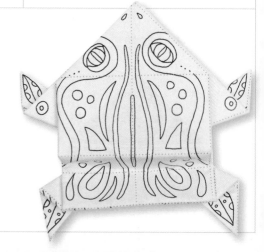

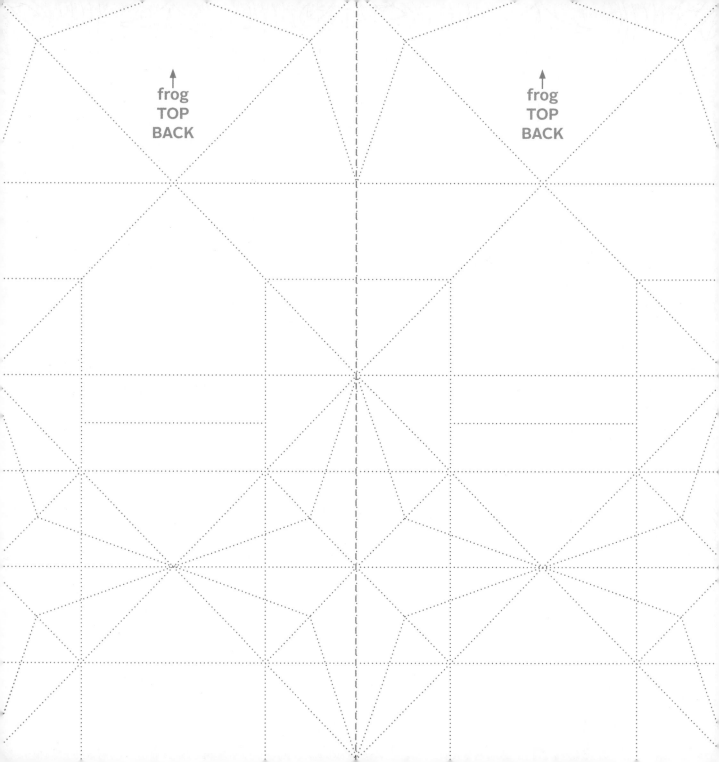

frog
TOP
BACK

frog
TOP
BACK

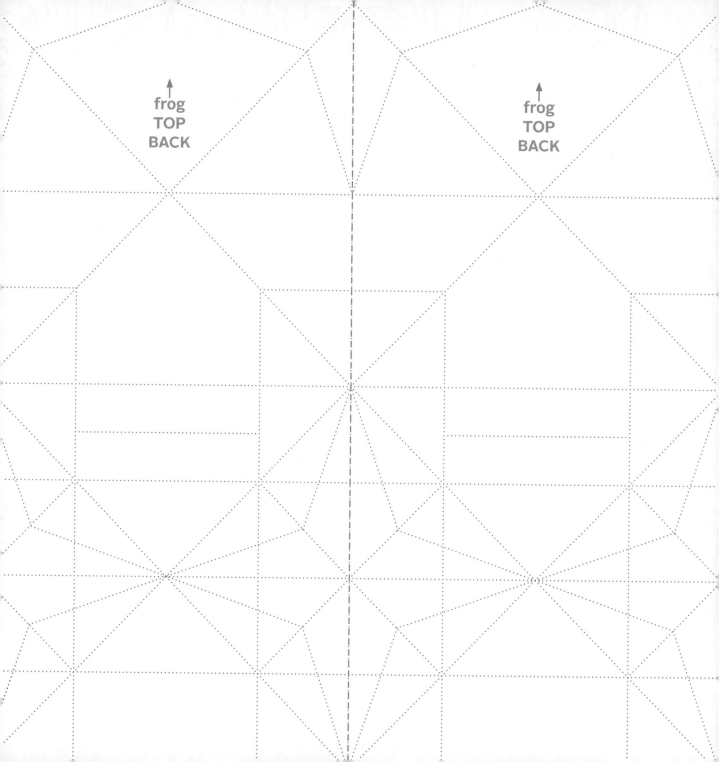

frog
TOP
BACK

frog
TOP
BACK

CRANE
INTERMEDIATE

1.
Start with the sheet positioned like this (front side up).

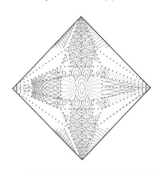

2.
Precrease the sheet along the diagonals. Turn the sheet over.

3.
Precrease the sheet in half in both directions.

4.
Bring the top and side corners to meet the bottom corner, using the creases made in Steps 2 and 3.

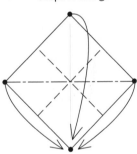

5.
Step 4 in progress.

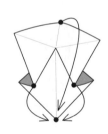

6.
Precrease the sides and top corner to the center on the guidelines.

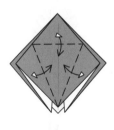

7.
Pull the flap up, allowing the sides to fold in toward the center, and flatten.

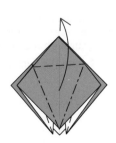

8.
Step 7 in progress.

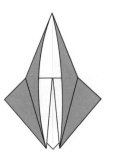

9.
Turn the Crane over.

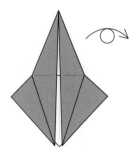

10.
Precrease the sides and top corner to the center on the guidelines.

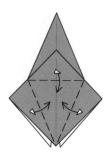

11.
Repeat Steps 7 and 8 on the indicated flap.

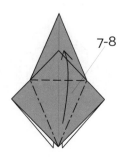

7-8

12.
Fold all four sides to the center on the guidelines.

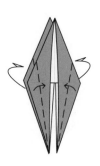

13.
Reverse fold the right point up on the guidelines to make the tail.

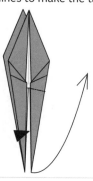

14.
Reverse fold the left point up on the guidelines to make the neck.

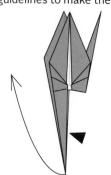

15.
Reverse fold the neck down to make the beak.

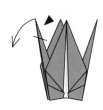

16.
Spread apart the wings, allowing the center point to open out a little.

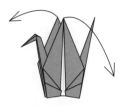

17.
Completed Crane.

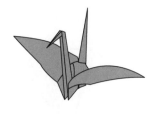

Tip: Make an ornament with the Crane by running string through the point between the wings.

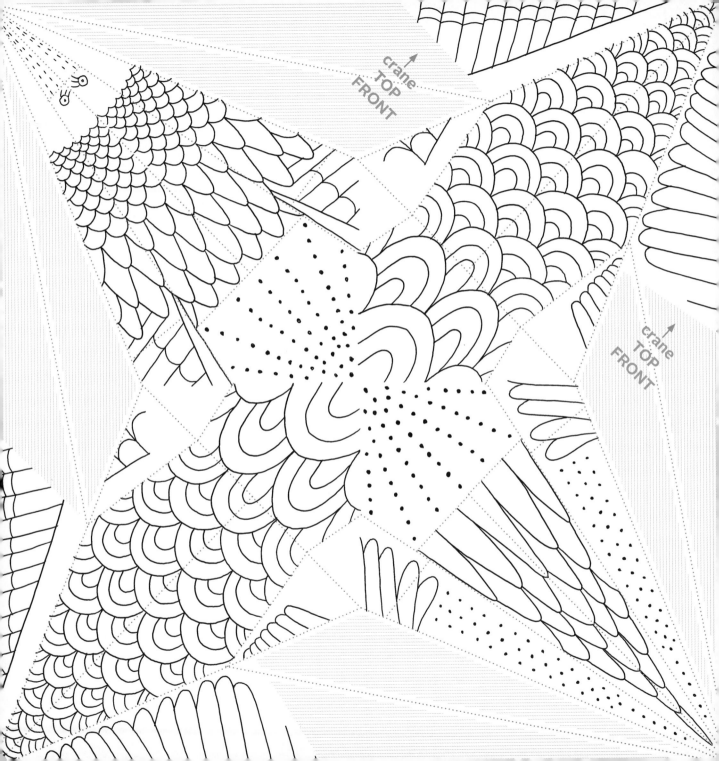

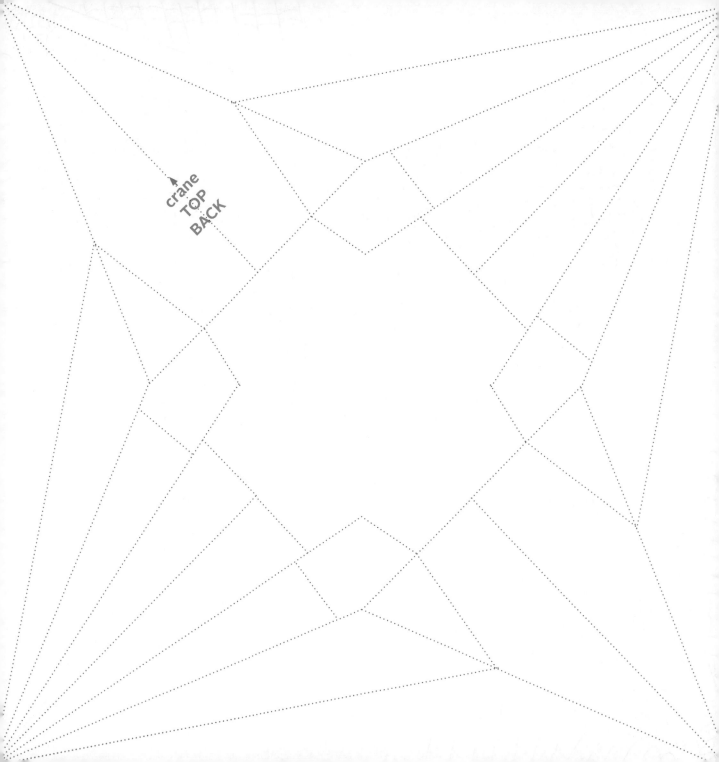

crane
TOP
BACK

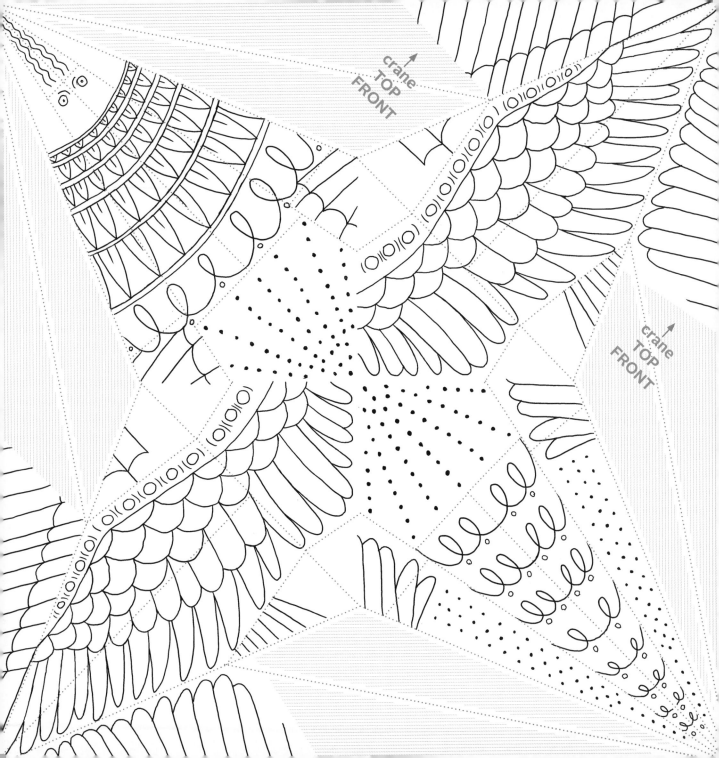

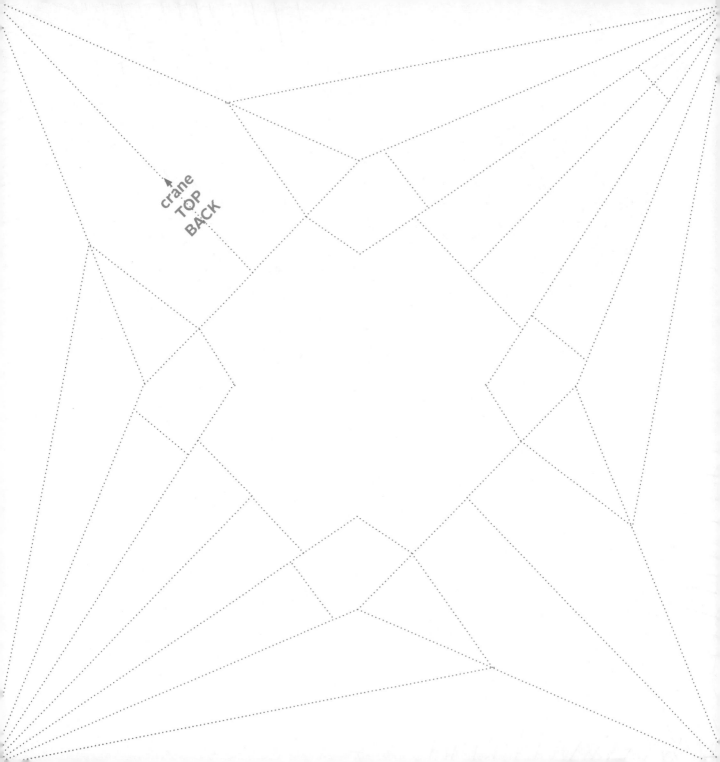

crane
TOP
BACK

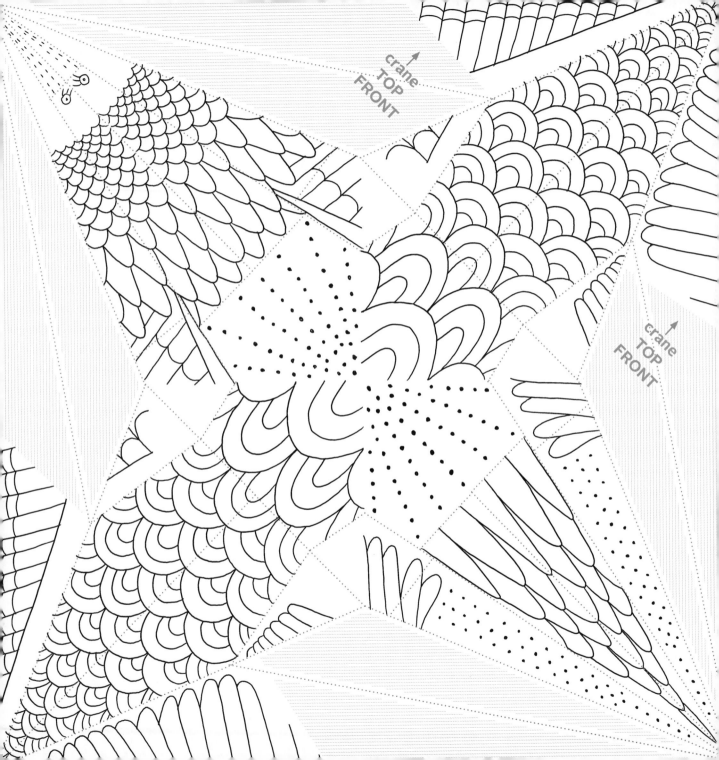

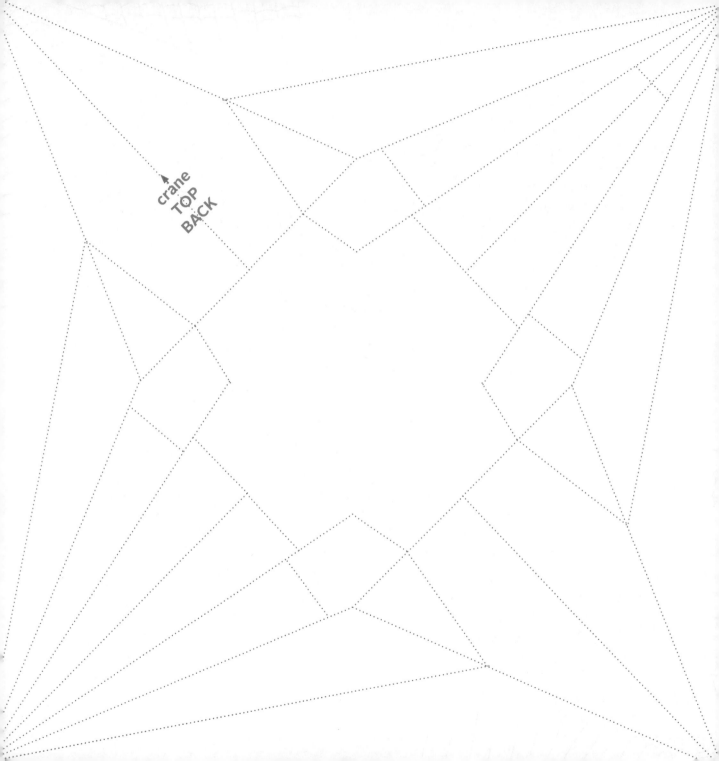

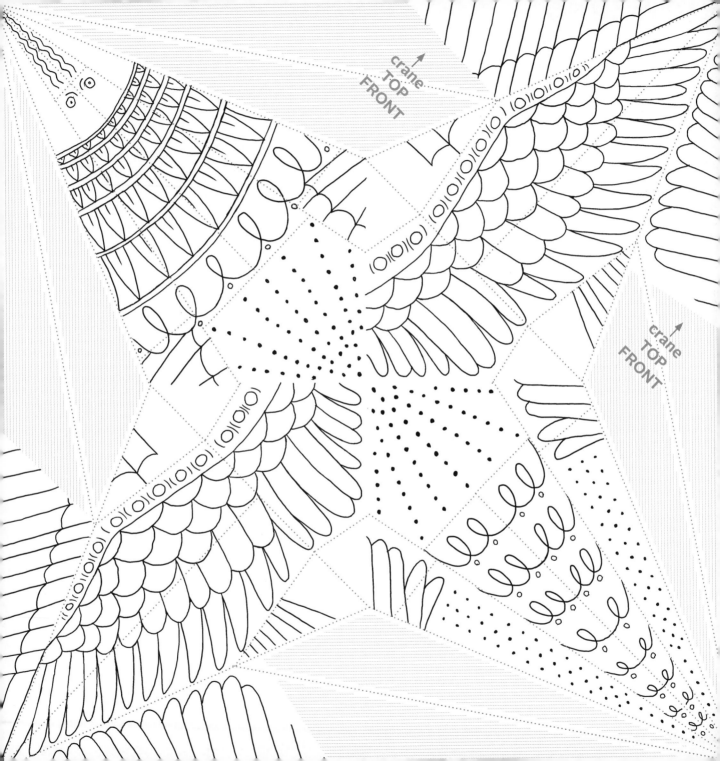

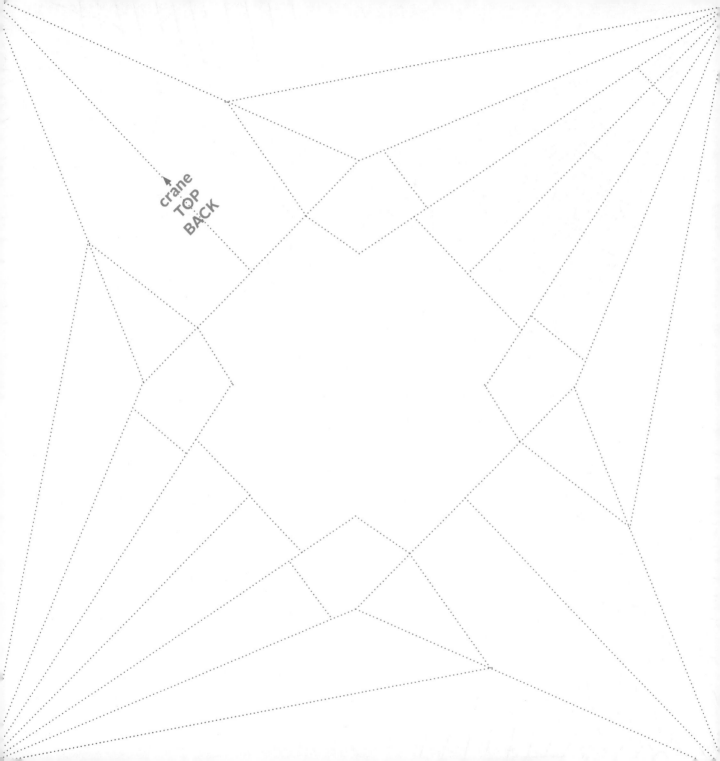

crane
TOP
BACK

TURTLE
INTERMEDIATE

1.
Start with the sheet positioned like this (front side up).

2.
Precrease the sheet along the diagonals. Turn the sheet over.

3.
Precrease the sheet in half in both directions.

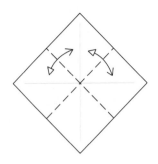

4.
Bring the top and side corners to meet the bottom corner, using the creases made in Steps 2 and 3.

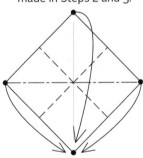

5.
Step 4 in progress.

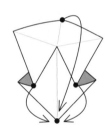

6.
Precrease the sides and the top corner to the center on the guidelines.

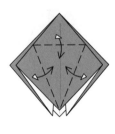

7.
Pull the flap up, allowing the sides to fold in toward the center, and flatten.

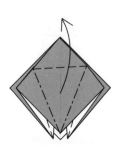

8.
Step 7 in progress.

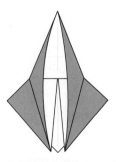

9.
Turn the Turtle over.

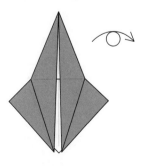

TURTLE CONTINUED

10.
Precrease the sides to the center on the guidelines.

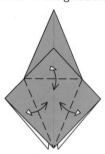

11.
Repeat Steps 7 and 8 on the indicated flap.

7-8

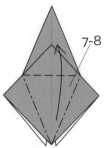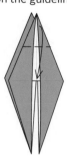

12.
Fold the top flap to the center on the guideline.

13.
Fold the flap up on the guideline.

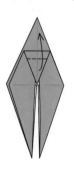

14.
Fold the tip down on the guideline.

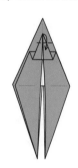

15.
Fold the top flap down.

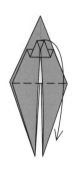

16.
Reverse fold the lower flaps outward on the guidelines.

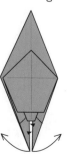

17.
Turn the Turtle over.

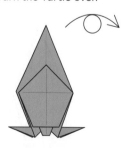

18.
Pleat the top flap down.

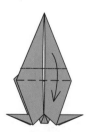

TURTLE CONTINUED

19.
Cut the top flap in half on
the orange dotted line.

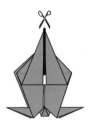

20.
Fold the two points outward
on the guidelines.

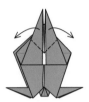

21.
Turn the Turtle over.

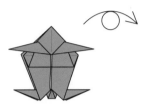

22.
Completed Turtle.

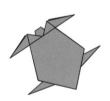

**Tip: Use double-sided tape to keep
the layers of the Turtle together.**

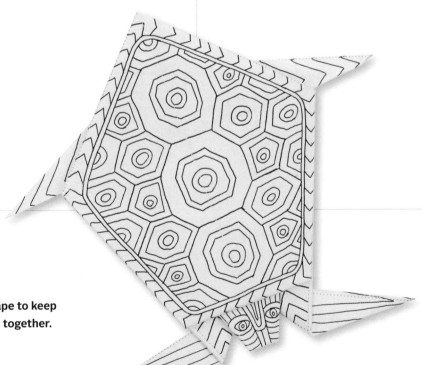

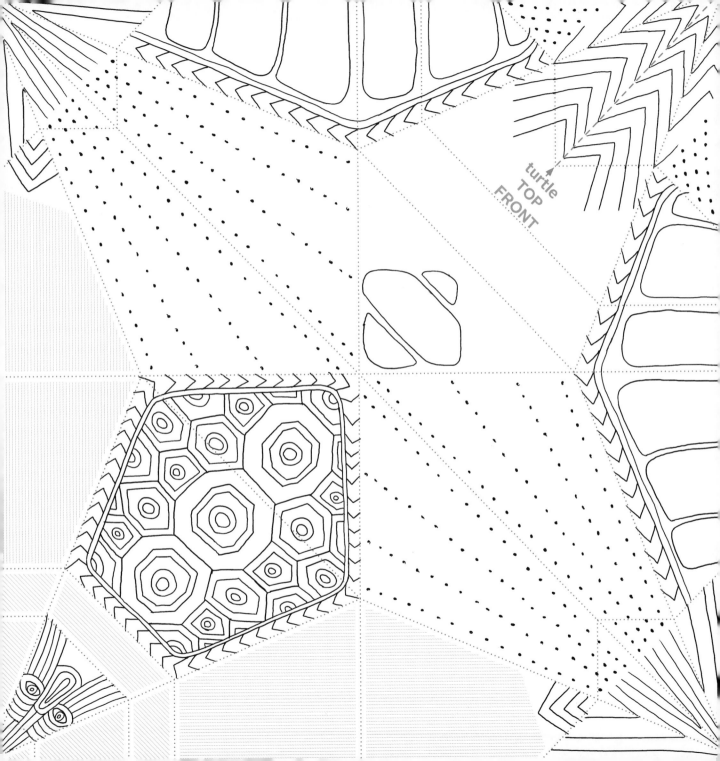

turtle
TOP
FRONT

turtle
TOP
BACK

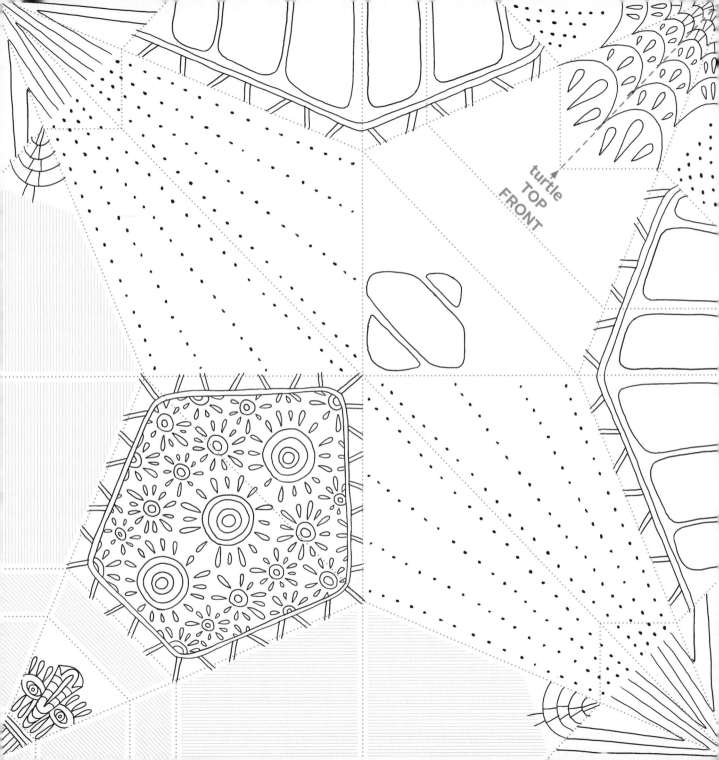

turtle
TOP
FRONT

turtle
TOP
BACK

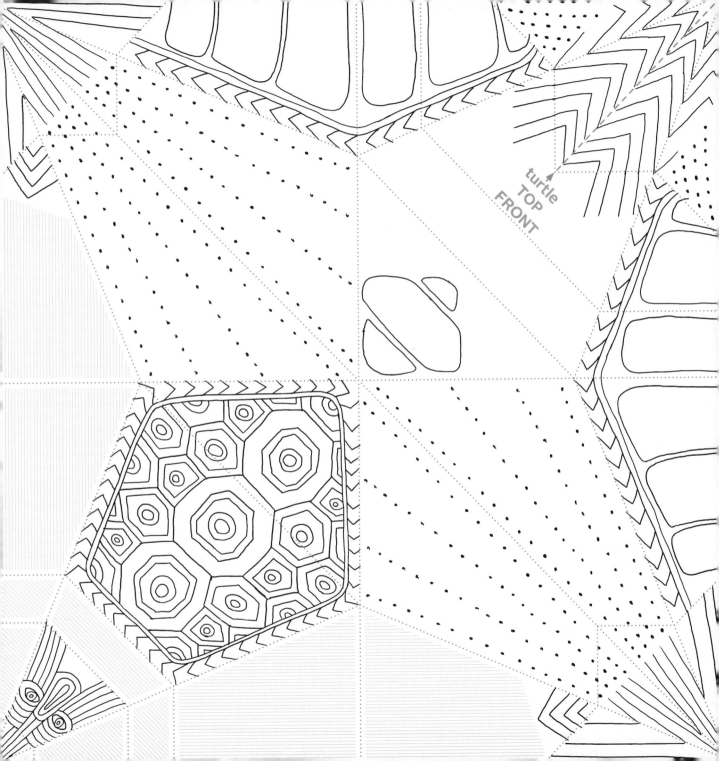

turtle
TOP
FRONT

turtle
TOP
BACK

ROOSTER

INTERMEDIATE

1.
Start with the sheet positioned like this (front side up).

2.
Precrease the sheet along the diagonals.

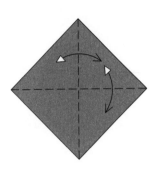

3.
Fold the top corner to the center on the guideline.

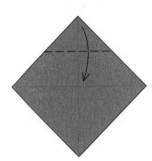

4.
Precrease the top corners along the guidelines. Turn the Rooster over.

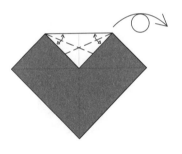

5.
Fold the sides to the center on the guidelines.

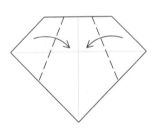

6.
Fold the corners up along the guidelines.

7.
Open out the two side flaps.

8.
Precrease both sides of the bottom point on the guidelines (first left, then right).

9.
Fold the bottom edges up, pinching the center point in half and pressing it flat to the right.

ROOSTER CONTINUED

10.
Fold the sides in to the center on the guidelines, placing the right side under the flap made in Step 9.

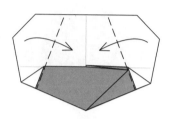

11.
Turn the Rooster over.

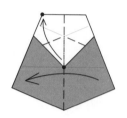

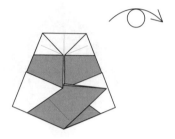

12.
Fold in half while folding the center point up to the dotted point, using the precreases. The tail will flip out.

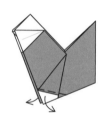

13.
Fold the flaps down on each side. Rotate the Rooster an ⅛ turn.

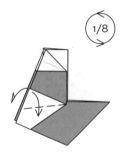

14.
Fold the flaps up so that the Rooster can stand upright on them.

15.
Reverse fold the tail down on the guidelines.

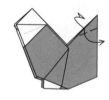

16.
Fold in the sides of the face on the guidelines so that the beak sticks out.

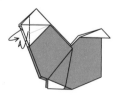

17.
Completed Rooster.

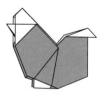

Tip: Use double-sided tape to keep the layers of the Rooster together.

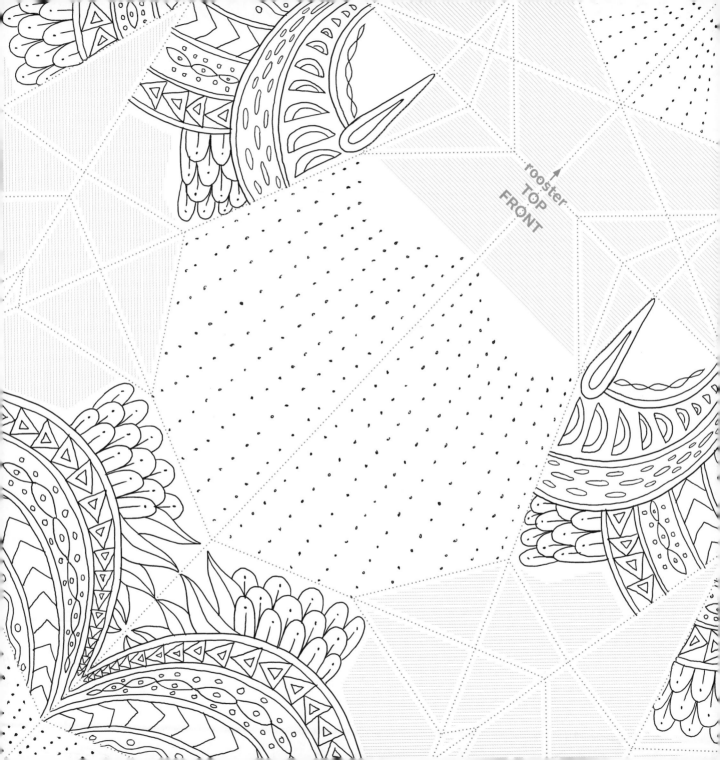

rooster
TOP
FRONT

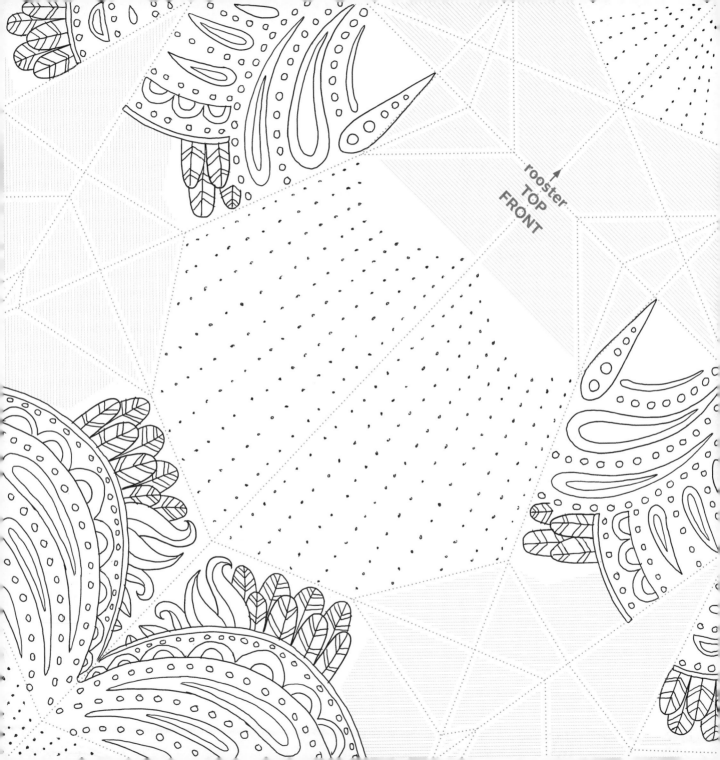

rooster
TOP
FRONT

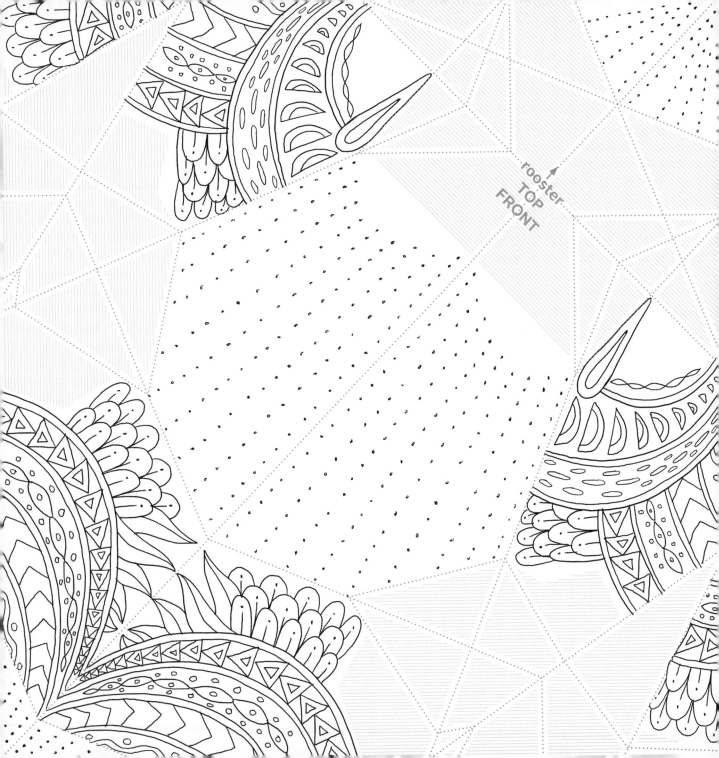

rooster
TOP
FRONT

DOG
INTERMEDIATE

1.
Start with the sheet positioned like this (front side up).

2.
Precrease the sheet in half along the diagonal.

3.
Fold the top point down on the second guideline from the top.

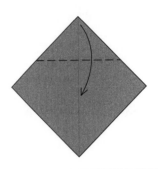

4.
Precrease both sides to the center on the guidelines.

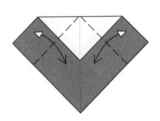

5.
Fold the sides to the center, reverse folding the indicated edges. A diamond-shaped flap will form at the top.

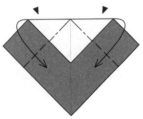

6.
Fold the top layer up on the guideline.

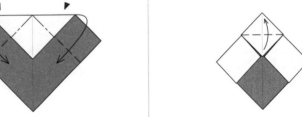

7.
Fold the sides out on the guidelines. Reverse fold the triangular folds so that they tuck under the top triangle.

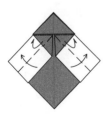

8.
Fold the top section behind.

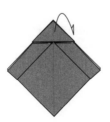

9.
Fold the bottom edges up on the guidelines, pinching the center flap to the right side.

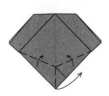

DOG CONTINUED

10.
Turn the Dog over.

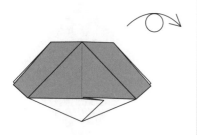

11.
Fold the top point up. Fold in the sides, pressing all layers flat.

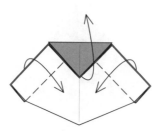

12.
Step 11 in progress. The layers in the top point will open up as the sides fold in. Press the top point down flat.

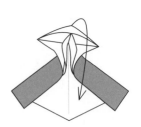

13.
Fold the two layers up together on the guidelines.

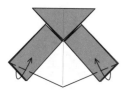

14.
Fold the sides to the center on the guidelines.

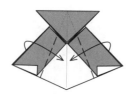

15.
Fold the left side behind the right.

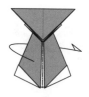

16.
Release the center pleat by pulling out the tail.

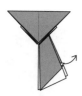

17.
Fold the corners down in front of the head to form ears. Reverse fold the tail down on the guidelines.

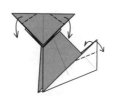

18.
Completed Dog.

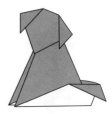

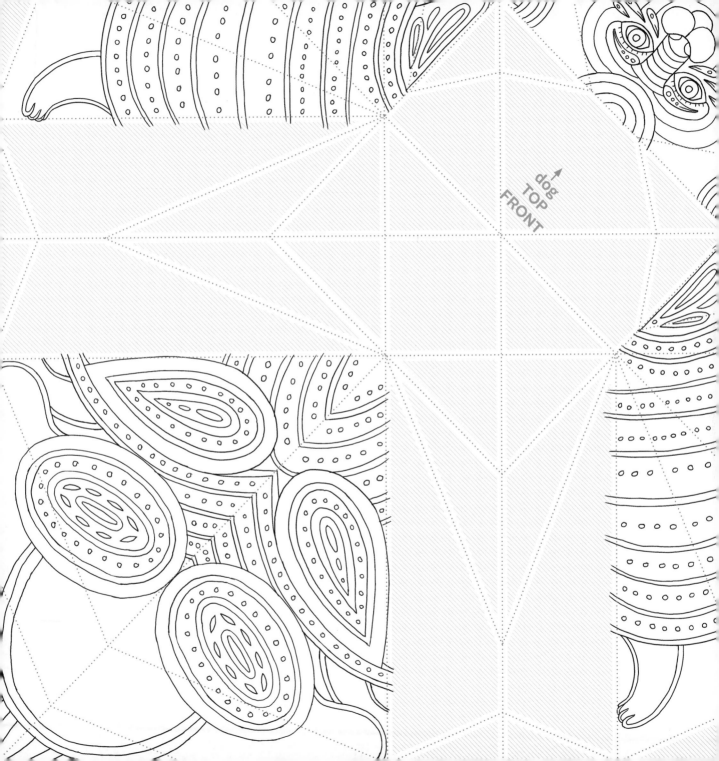

dog
TOP
FRONT

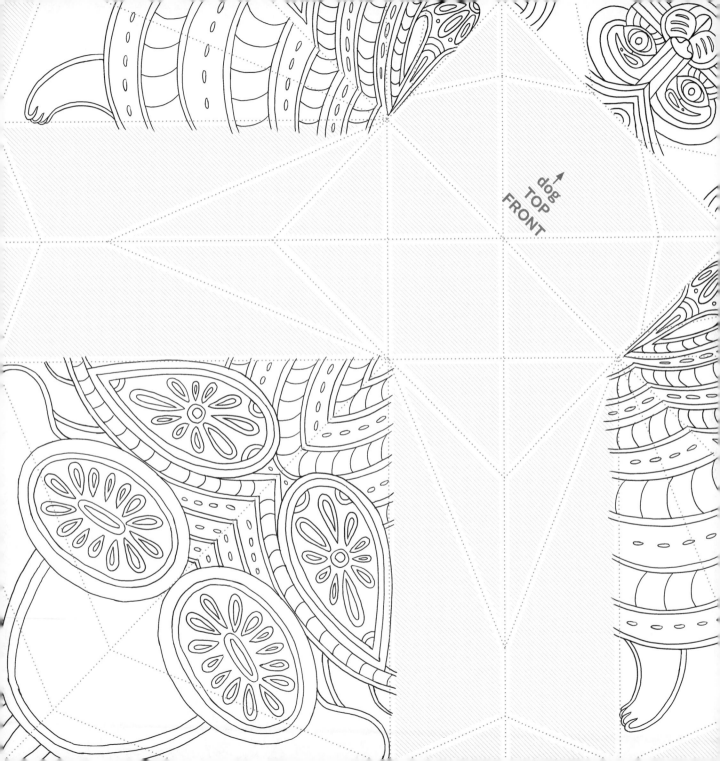

dog
TOP
FRONT

CAT
INTERMEDIATE

1.
Start with the sheet positioned like this
(front side up).

2.
Precrease the sheet in half
along the diagonal.

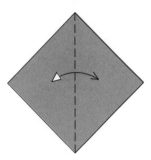

3.
Fold the top point down on
the second guideline from the top.

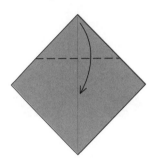

4.
Precrease both sides to
the center on the guidelines.

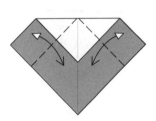

5.
Fold the sides to the center, reverse
folding the indicated edges. A diamond-
shaped flap will form at the top.

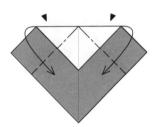

6.
Fold the top layer up on the guideline.

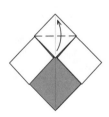

7.
Fold the sides out on the guidelines.
Reverse fold the triangular folds so
that they tuck under the top triangle.

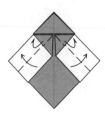

8.
Fold the top section behind.

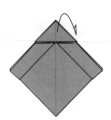

9.
Fold the bottom edges up
on the guidelines, pinching
the center flap to the right side.

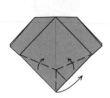

CAT CONTINUED

10.
Turn the Cat over.

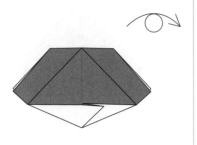

11.
Fold the top point up. Fold in the sides, pressing all layers flat.

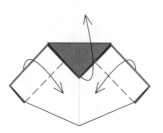

12.
Step 11 in progress. The layers in the top point will open up as the sides fold in. Press the top point down flat.

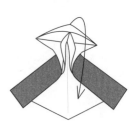

13.
Fold the two layers up together on the guidelines.

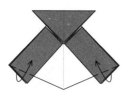

14.
Fold the sides to the center on the guidelines.

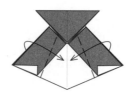

15.
Fold the left side behind the right.

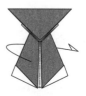

16.
Release the center pleat by pulling out the tail.

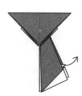

17.
Fold the corners down behind the head and then fold them back up to form ears.

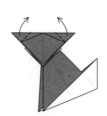

18.
Completed Cat.

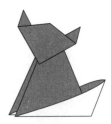

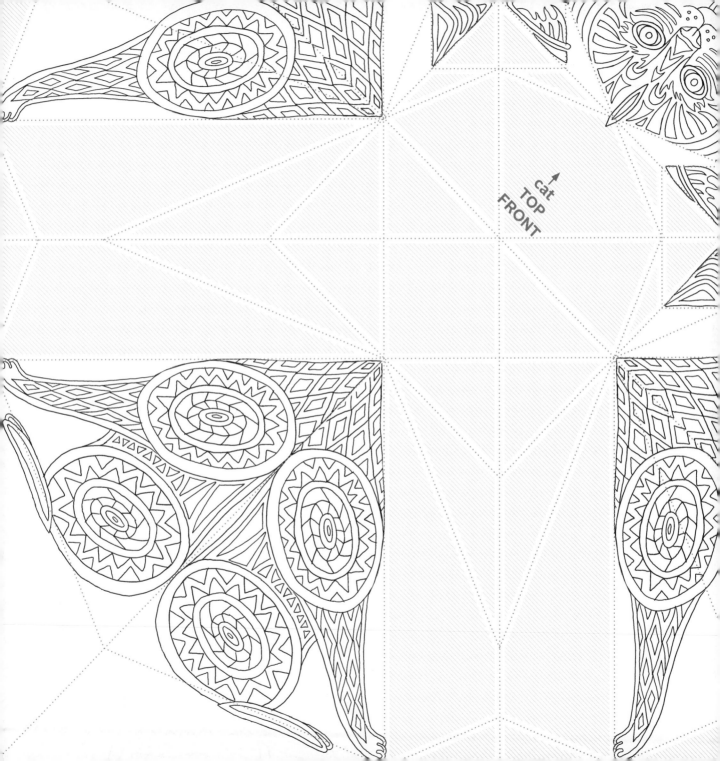

cat
TOP
FRONT

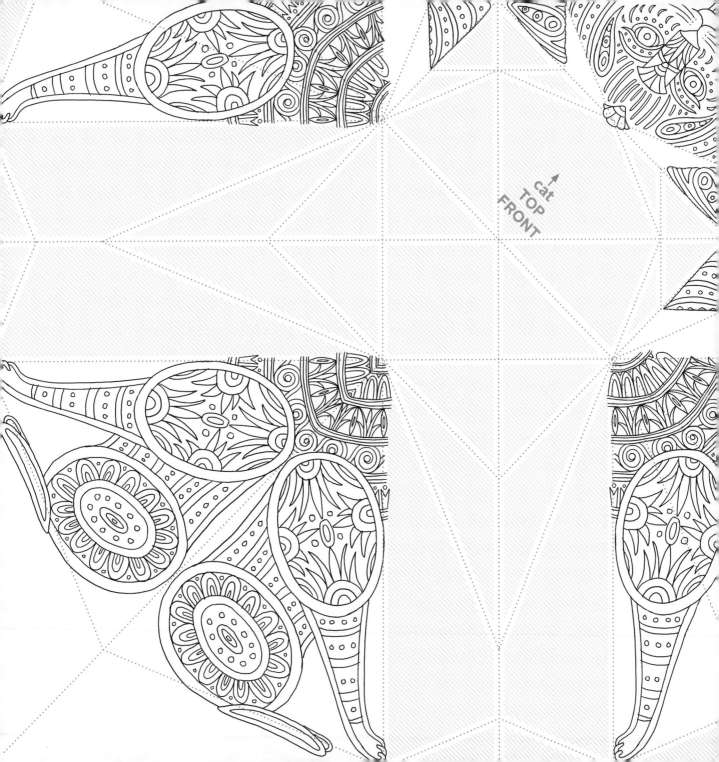

cat
TOP
FRONT

LION

1.
Begin with the sheet positioned like this (front side up).

2.
Precrease the sheet along the diagonals.

3.
Fold the corners to the center along the guidelines.

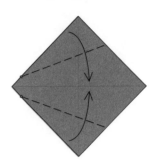

4.
Fold the corners outward on the guidelines.

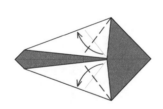

5.
Fold the Lion in half (top behind bottom) and rotate it an ⅛ turn.

1/8

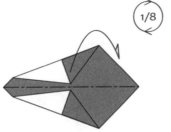

6.
Precrease at the guideline.

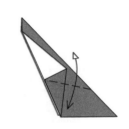

7.
Reverse fold the flap, starting from the crease made in Step 6.

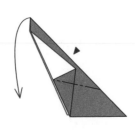

8.
Reverse fold the flap upward on the guideline.

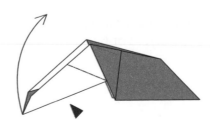

9.
Reverse fold the corner down on the guideline.

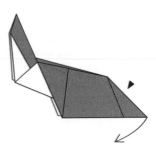

10.
Reverse fold the corner outward,
using the guidelines.

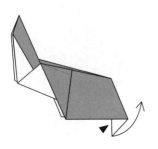

11.
Fold the front section over so that
the corner meets the top edge
at the dotted point.

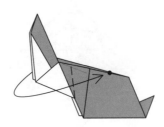

12.
Open out the flap.

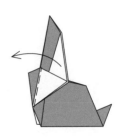

13.
Fold the top point down on the guideline.

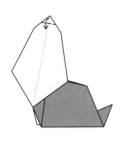

14.
Fold the face flap down on the guideline.

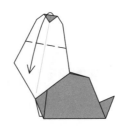

15.
Completed Lion.

Tip: The Lion tends to be top-heavy, but he'll stand upright if you attach a paper clip to his back hindquarters. Secure the layers of his head with double-sided tape if needed.

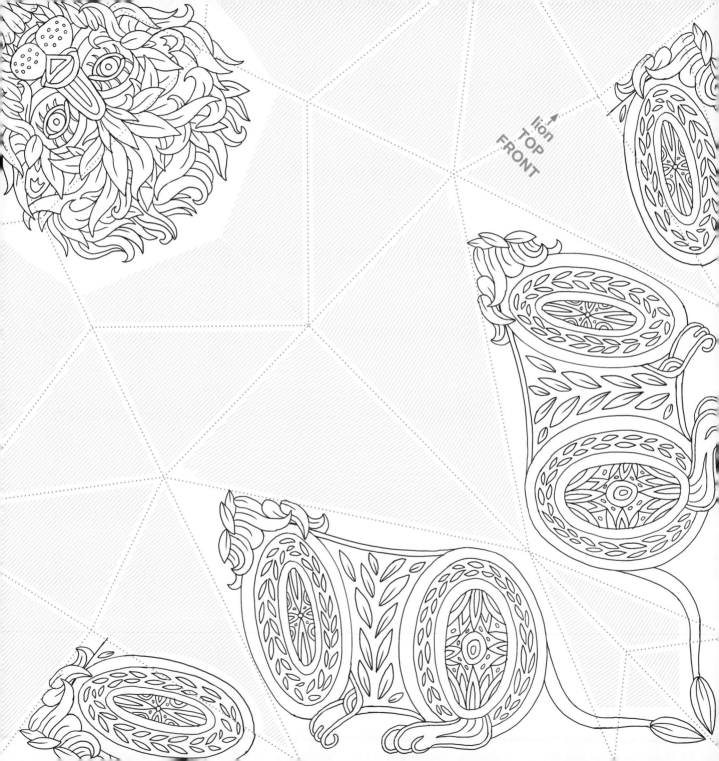

lion
TOP
FRONT

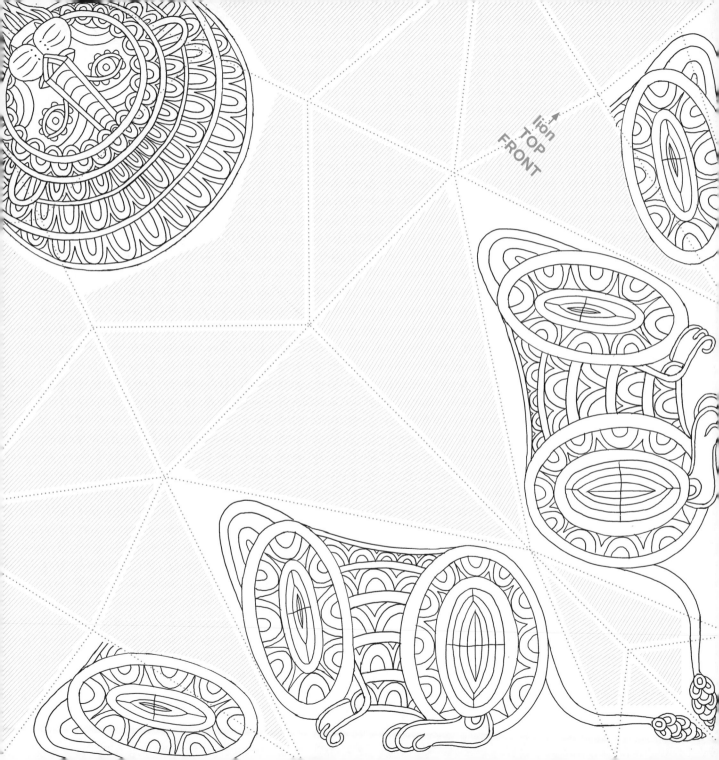

lion
TOP
FRONT

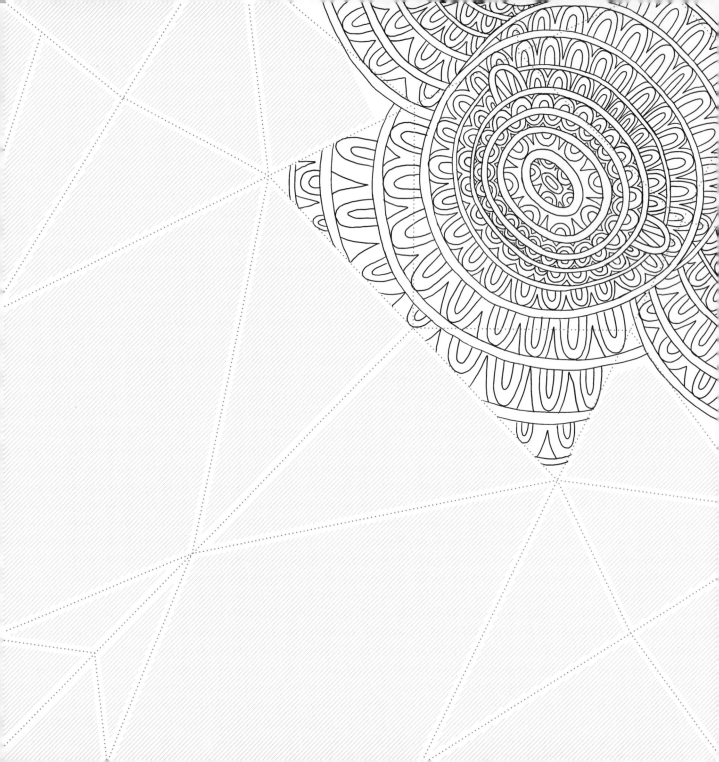

FOX
INTERMEDIATE

1.
Start with the sheet positioned like this (back side up).

2.
Precrease the sheet along the diagonals.

3.
Fold the sides to the center on the guidelines.

4.
Fold the corners outward on the guidelines. Fold the bottom point up on the guideline.

5.
Fold the Fox in half (left side behind right).

6.
Reverse fold the bottom up on the guidelines.

7.
Fold down the side flaps on the guidelines.

8.
Open out the top flap.

9.
Fold the sides to the center on the guidelines.

FOX CONTINUED

10.
Fold the flap down.
Rotate the Fox an ⅛ turn.

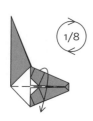

11.
Precrease the flap on the
indicated guideline.

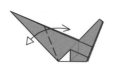

12.
Reverse fold the long edge of the flap
using the crease formed in Step 11
and press it flat to match the illustration
in Step 13.

13.
Fold the top point down on the guideline,
then fold the flap down on the guideline.

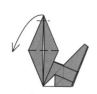

14.
Fold the snout up on the guideline.

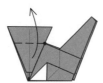

15.
Fold the sides of the snout down on the
slanted guidelines and pinch it half.

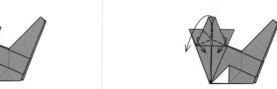

16.
Fold the left side of the face
behind the right.

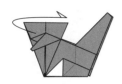

17.
Reverse fold the top edge to shape
the pointed ears.

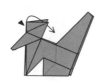

18.
Completed Fox.

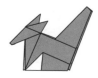

fox
TOP
BACK

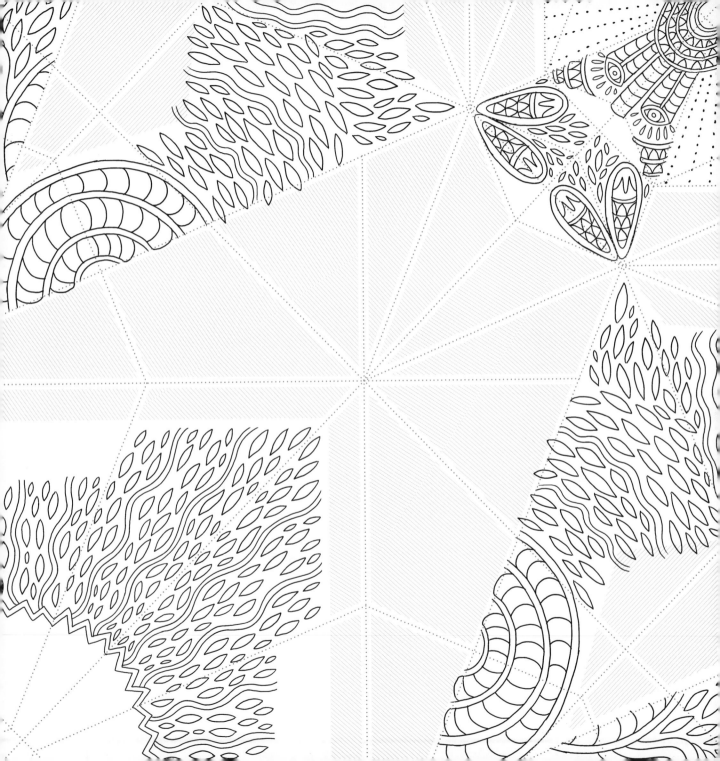

fox
TOP
BACK

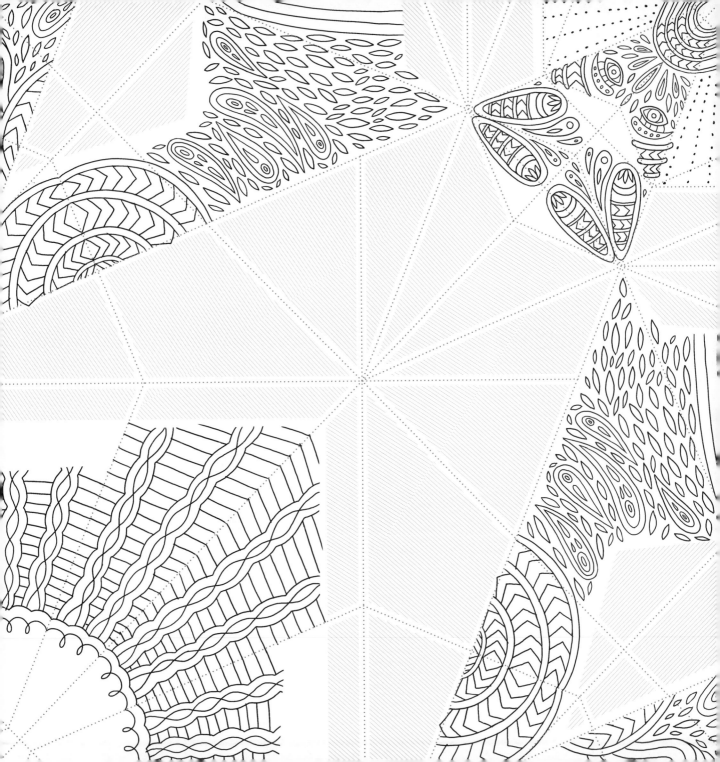

fox
TOP
BACK

RABBIT
ADVANCED

1.
Start with the sheet positioned like this (back side up).

2.
Precrease the sheet in half.

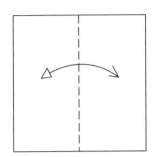

3.
Fold the sides to the center.

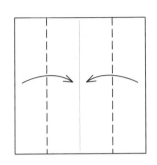

4.
Reverse fold the top corners on the guidelines.

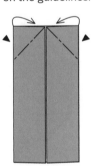

5.
Turn the Rabbit over.

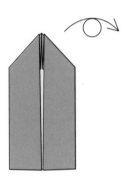

6.
Fold the top flap down.

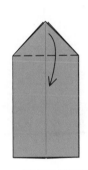

7.
Pull the top layers outward, allowing the bottom point to pull up, and press flat on the guidelines.

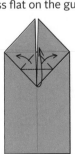

8.
Fold the bottom corners to the center on the guidelines.

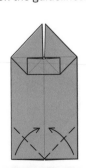

9.
Fold the bottom corner up.

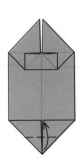

10.
Fold the bottom flap down
on the guideline.

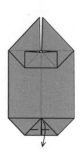

11.
Fold the bottom section
up on the guideline.

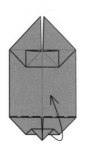

12.
Fold the bottom section behind
on the guideline.

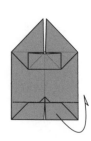

13.
Fold the corners in on the guidelines
to match the edges behind.

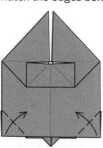

14.
Fold in half (right side over left).

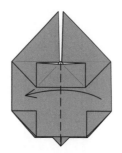

15.
Fold the top flap down on the guideline.
Fold the back flap behind on the guideline.

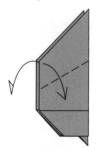

16.
Fold the edges up on the guidelines
to form the ears.

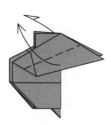

17.
Pull the flaps out, releasing the pleats.

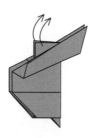

18.
Fold the flaps down along
the existing creases.

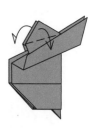

19.
Pull out the center hidden flap.
Rotate the Rabbit an ⅛ turn.

1/8

20.
Completed Rabbit

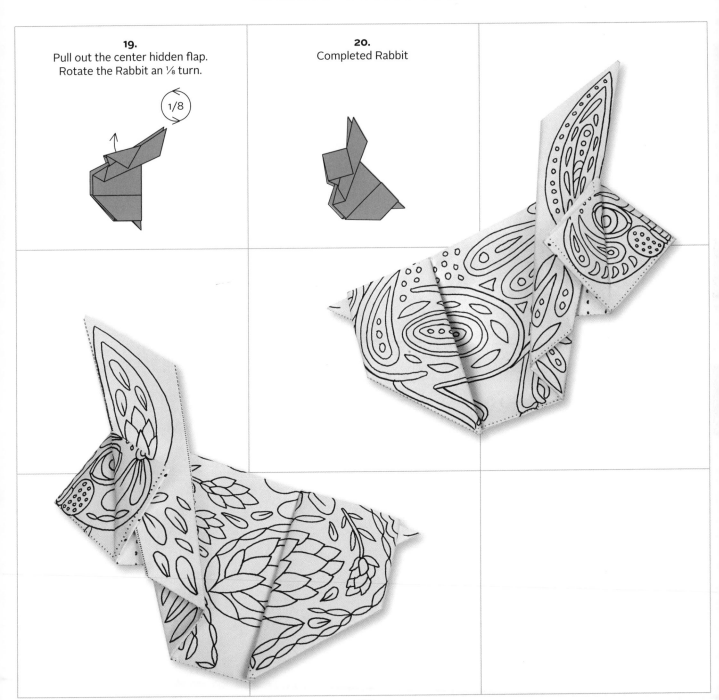

rabbit
TOP
BACK

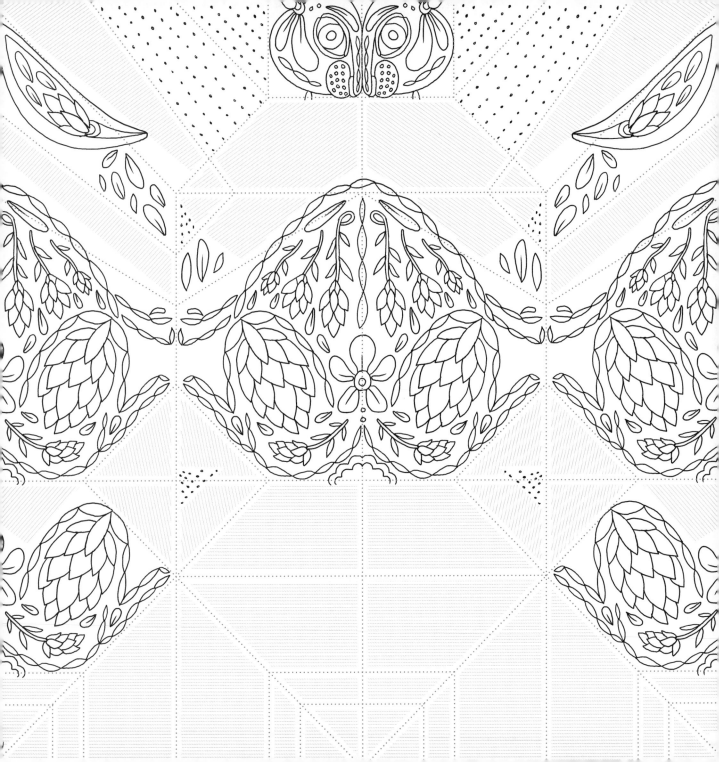

rabbit
TOP
BACK

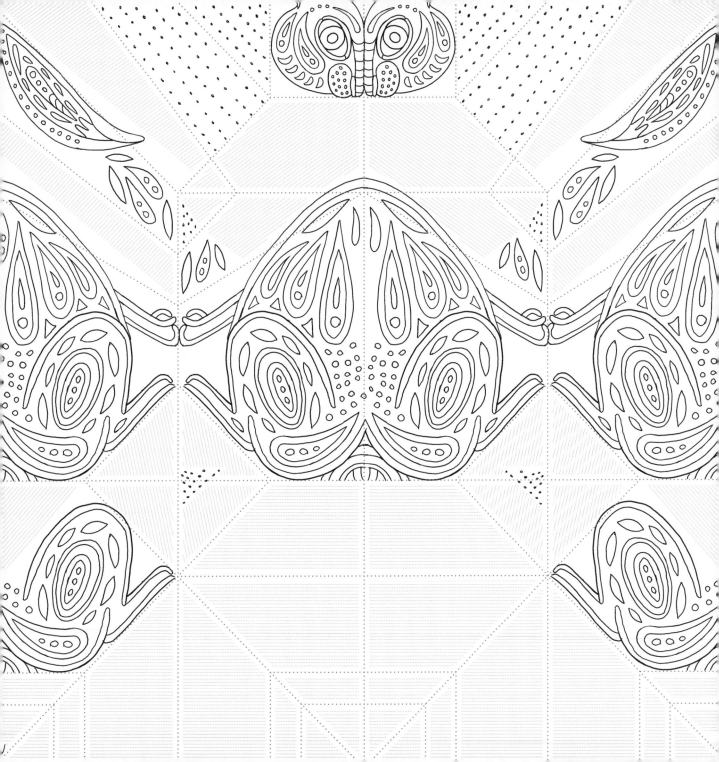

rabbit
TOP
BACK

SQUIRREL
ADVANCED

1.
Start with the sheet positioned like this (back side up).

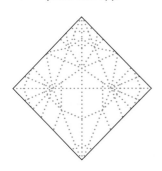

2.
Precrease the sheet along the diagonals.

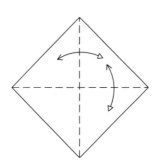

3.
Precrease the sides to the center.

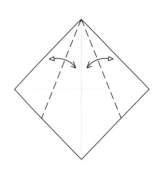

4.
Fold the sides to the center on the guidelines.

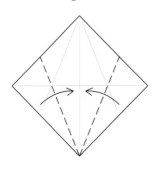

5.
Fold the bottom point behind at the guideline.

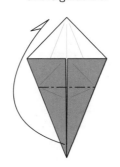

6.
Pull the corners down, allowing the sides to fold in and flatten at the center.

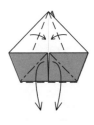

7.
Fold the flaps up on the guidelines.

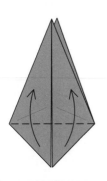

8.
Fold the right flap down on the guideline.

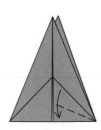

9.
Fold the flap over on the guideline.

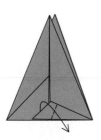

10.
Repeat Steps 8 and 9 on the left flap.

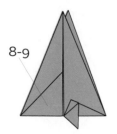

8-9

11.
Crease the top flap on the slanted guidelines. Then fold it down to the right, pinching it half.

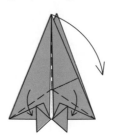

12.
Step 11 in progress.
Press the flap flat to the right.

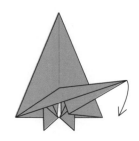

13.
Reverse fold the flap down on the guidelines.

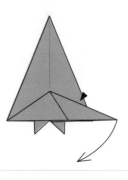

14.
Reverse fold the tip of the flap back on the guidelines.

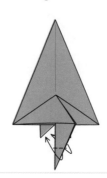

15.
Precrease by folding the top corner down to each of the side corners on the guidelines.

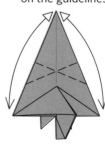

16.
Fold in half (right side behind left).

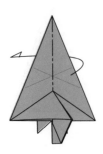

17.
Reverse fold the tail at the guidelines.

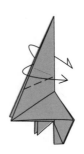

18.
Fold the feet out on the guidelines.
Rotate the Squirrel a ¼ turn.

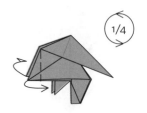

1/4

SQUIRREL CONTINUED

19.
Open and fold down the sides of the face on the diagonal guidelines.

20.
Reverse fold the tip of the tail out.

21.
Pull the head up by folding both sides of the face in at the indicated guidelines.

22.
Completed Squirrel.

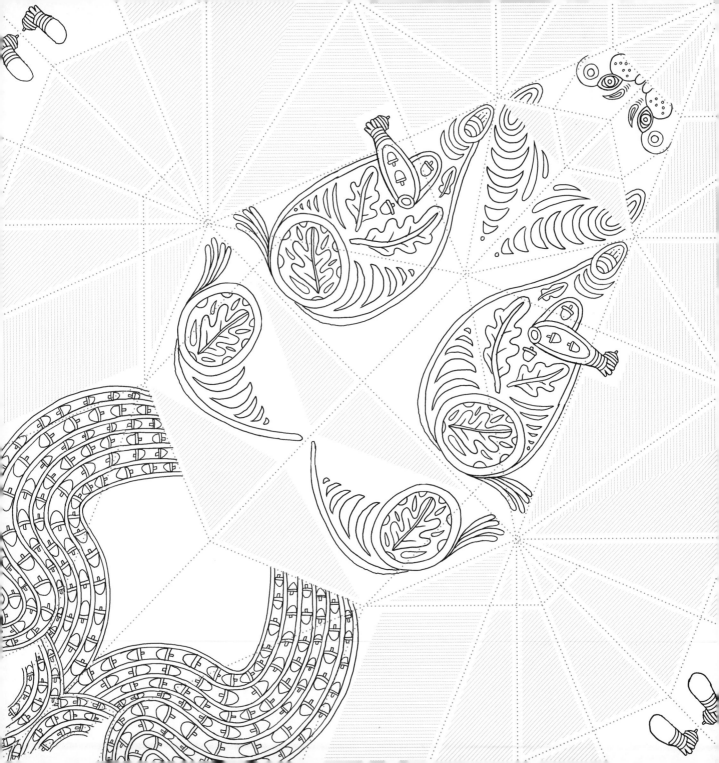

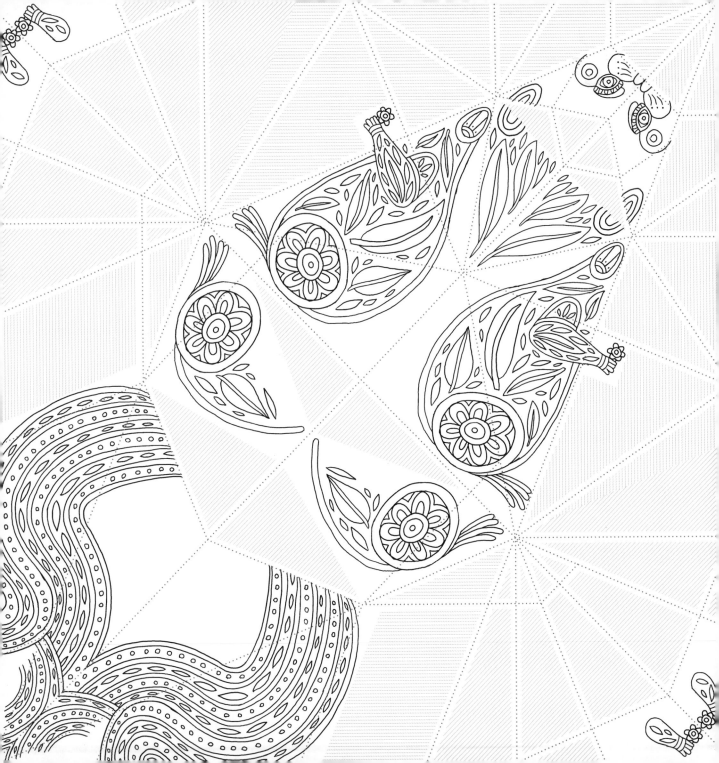

squirrel TOP BACK

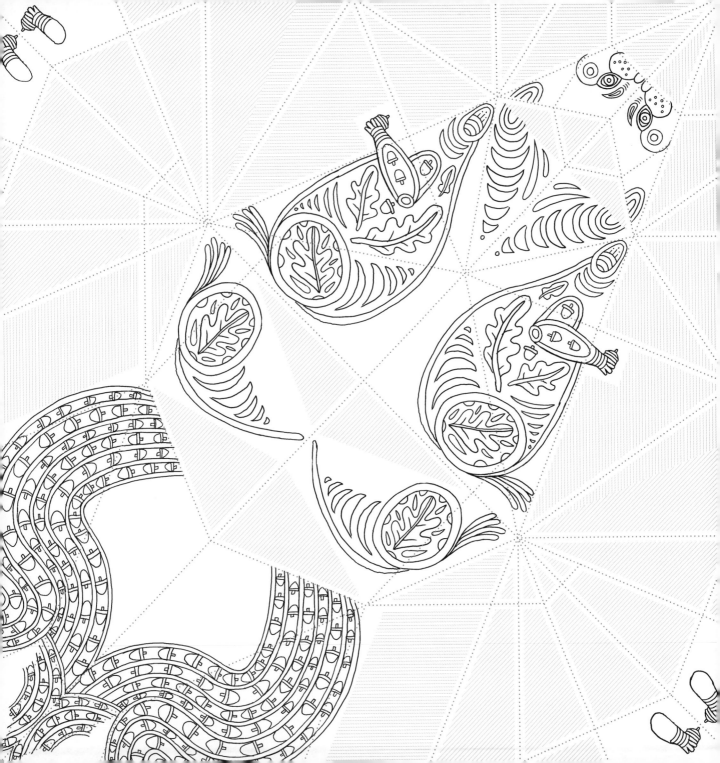

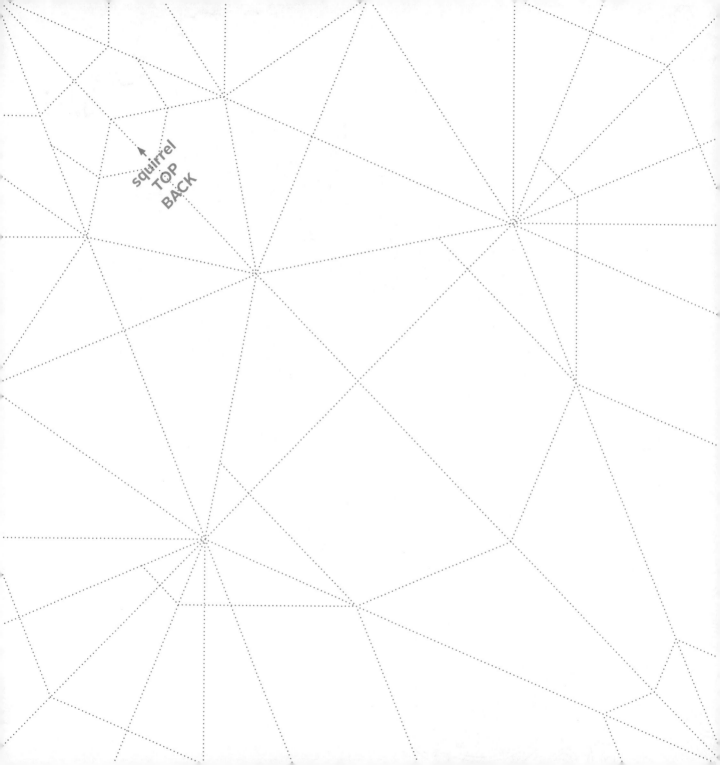

squirrel
TOP
BACK

ELEPHANT
ADVANCED

1.
Start with the sheet positioned like this (front side up).

2.
Precrease the sheet along the diagonals.

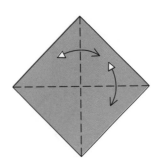

3.
Fold the side corners in and the bottom corner behind on the guidelines.

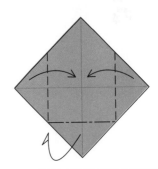

4.
Precrease the bottom corners in.

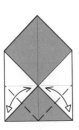

5.
Bring the bottom points to the center, allowing the layers to open and press flat.

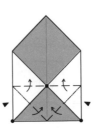

6.
Step 5 in progress.

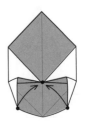

7.
Fold the two flaps out to the sides on the guidelines, allowing the bottom point to pull up and flatten.

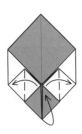

8.
Step 7 in progress.

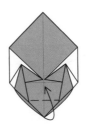

9.
Fold out the flaps on the two small triangles. Fold down the bottom point from the back of the Elephant. Turn the Elephant over.

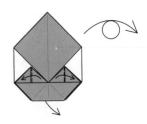

ELEPHANT CONTINUED

10.
Fold the sides to the center on the guidelines.

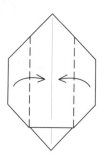

11.
Lift the top layers of the diamond-shaped flaps and press the indicated edges flat.

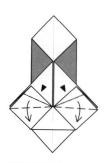

12.
Fold the sides in on the guidelines to form the trunk.

13.
Fold the trunk down on the guideline.

14.
Turn the Elephant over.

15.
Fold the top edge down on the guideline, allowing the trunk to flip up.

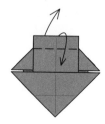

16.
Fold the right side behind the left. Rotate the Elephant a ¼ turn.

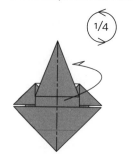

17.
Reverse fold the tail in on the vertical guidelines and then out on the slanted guidelines.

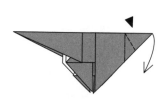

18.
Reverse fold the trunk down on the guidelines.

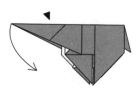

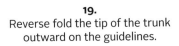

ELEPHANT CONTINUED

19.
Reverse fold the tip of the trunk outward on the guidelines.

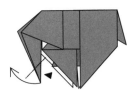

20.
Fold the points of each foot behind on the guidelines.

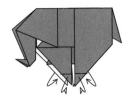

21.
Completed Elephant.

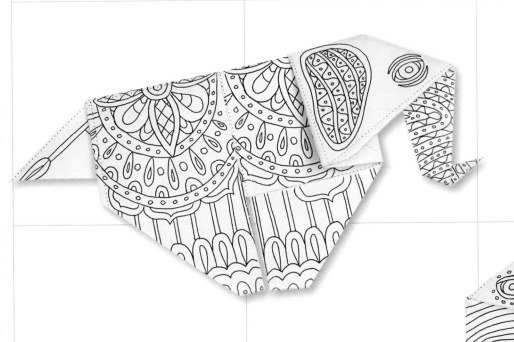

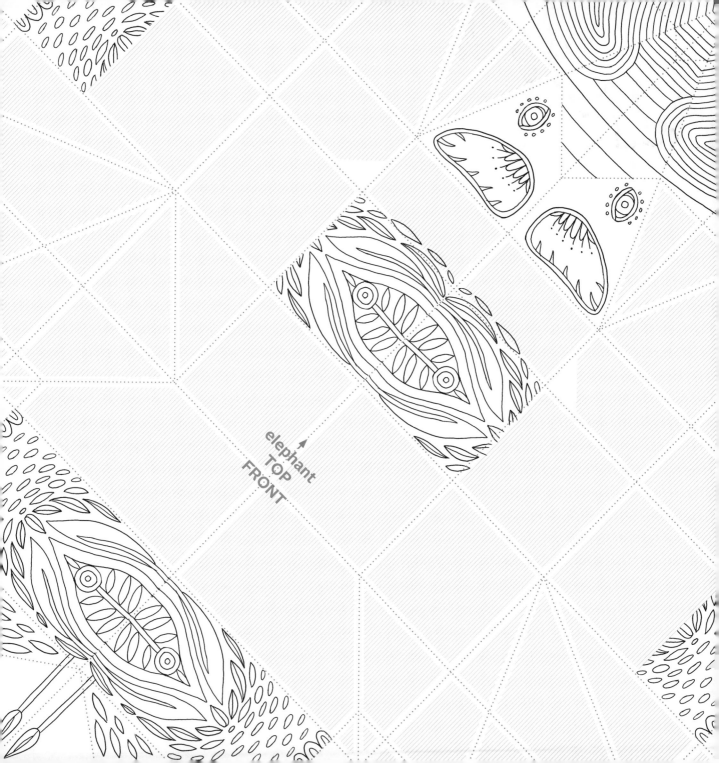

elephant
TOP
FRONT

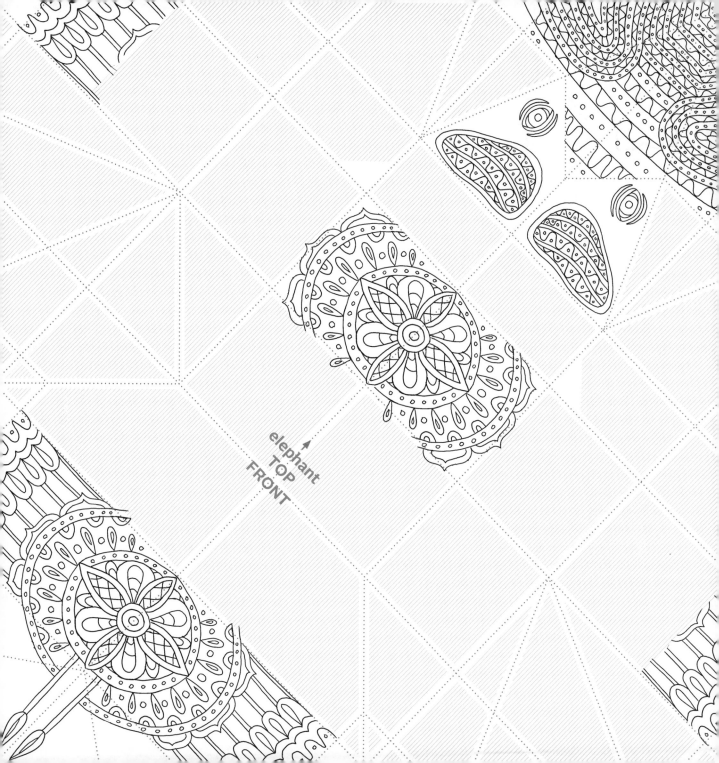

elephant
TOP
FRONT

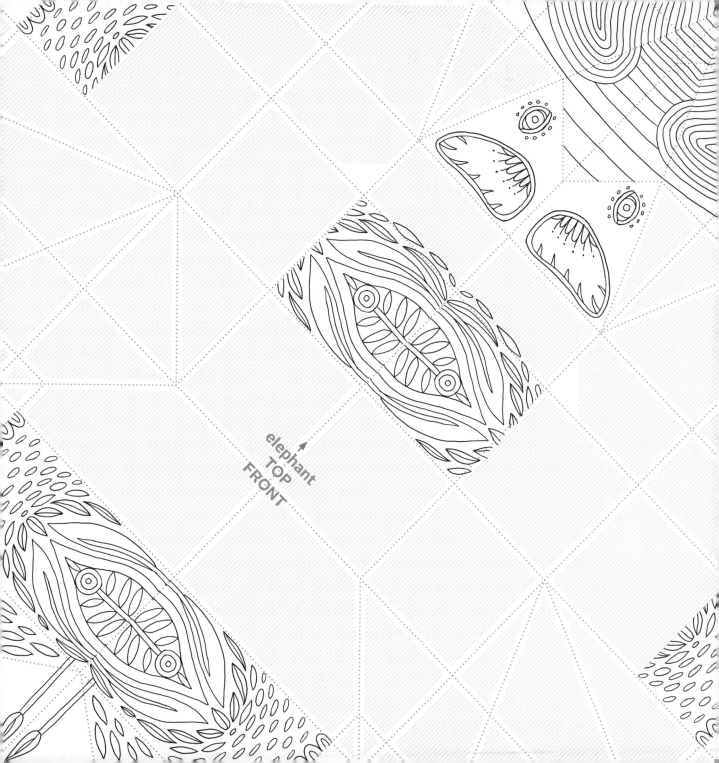

elephant
TOP
FRONT

PEACOCK
ADVANCED

1.
Start with the sheet positioned like this (back side up).

2.
Precrease the sheet in half along the diagonal.

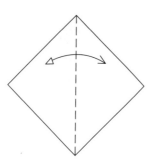

3.
Precrease the sides to the center on the guidelines.

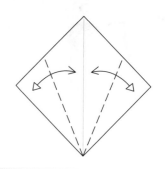

4.
Precrease the upper corners on the guidelines.

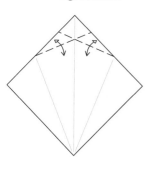

5.
Fold down on the guideline at the intersection of creases.

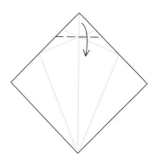

6.
Fold the corners down on the guidelines.

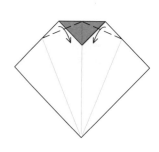

7.
Precrease each section in half.

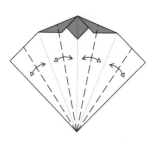

8.
Starting from the outside edges, pleat both sides behind by folding the dotted guidelines between the previous creases.

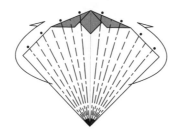

9.
Fold in half (bottom behind top).

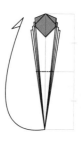

10.
Fold the bottom edge to the dotted point, allowing the flap from behind to swing forward.

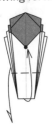

11.
Turn the Peacock over.

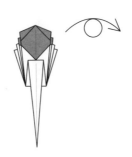

12.
Fold the bottom tip up as indicated.

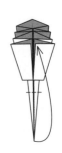

13.
Fold the Peacock in half (right side behind left). Rotate the Peacock a ¼ turn.

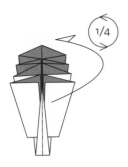

14.
Pull the neck upward.

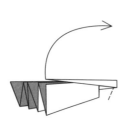

15.
Fold the point down to form the beak.

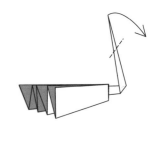

16.
Slide the pleated section straight up.

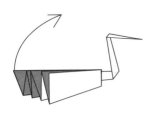

17.
Open out the pleats.

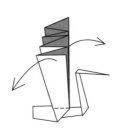

18.
Completed Peacock.

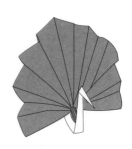

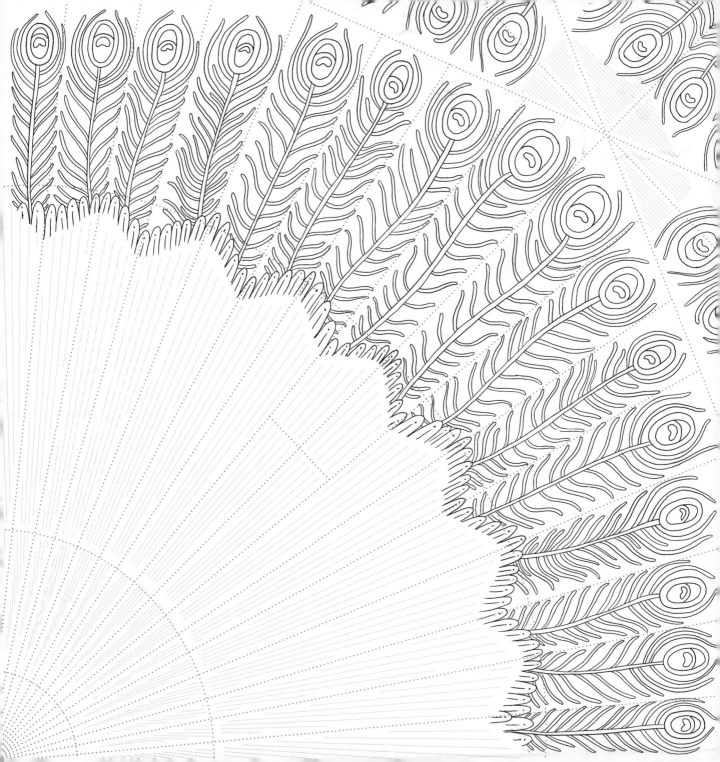

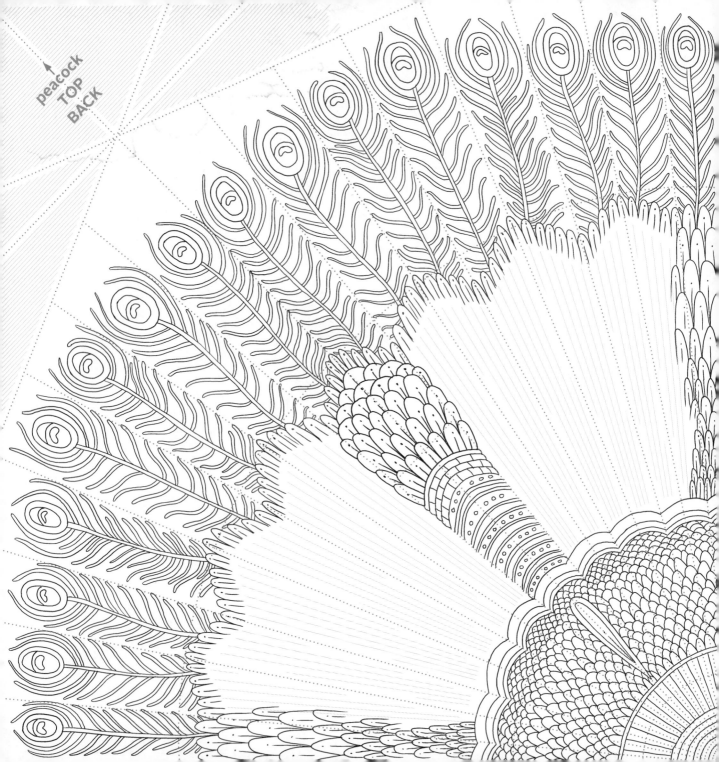

peacock
TOP
BACK

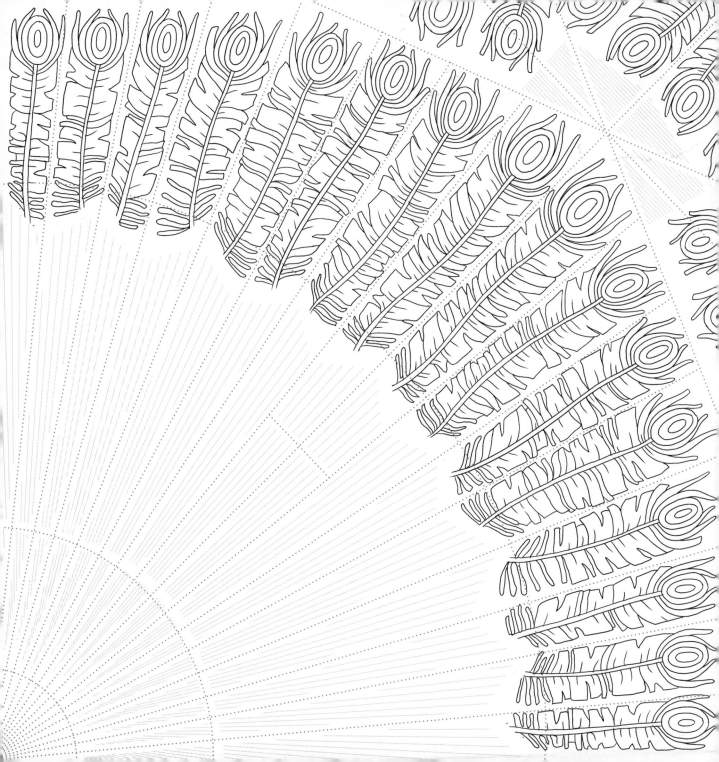

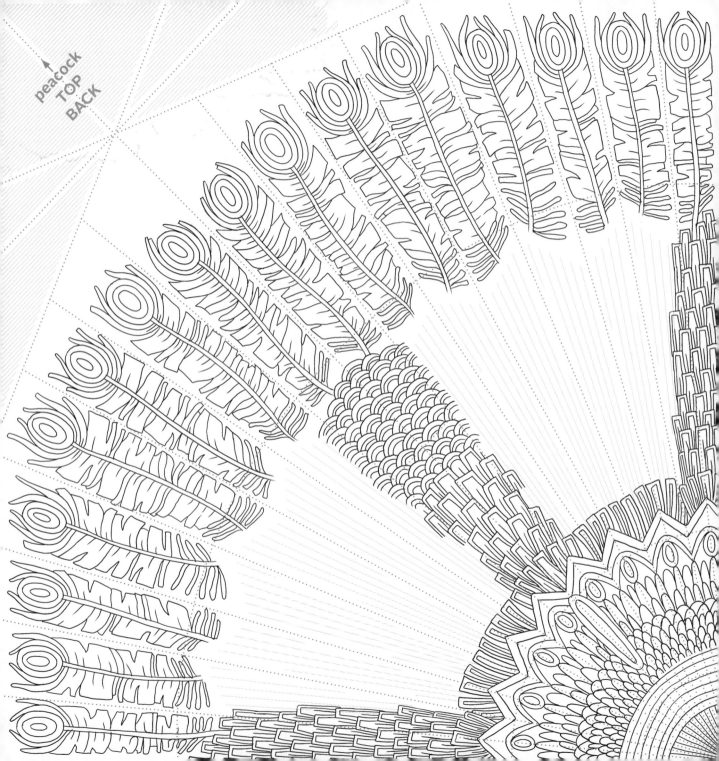

peacock
TOP
BACK

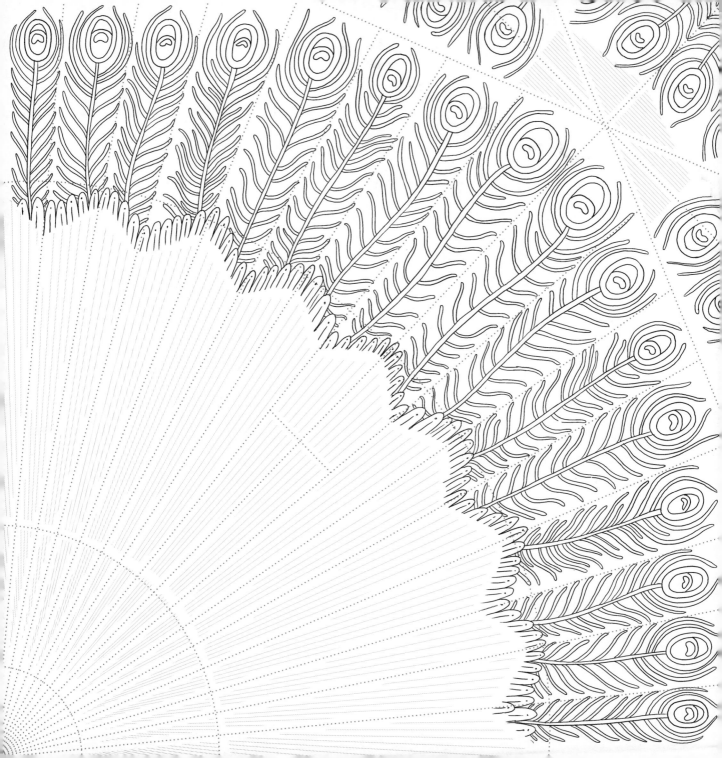

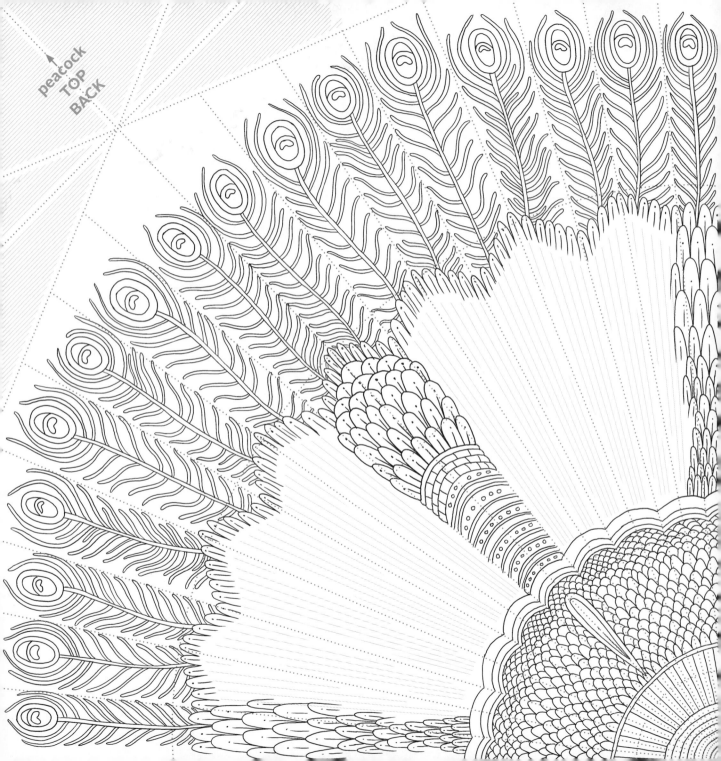

GIRAFFE
ADVANCED

1.
Start with the sheet positioned like this (front side up).

2.
Precrease the sheet along the diagonals. Turn over.

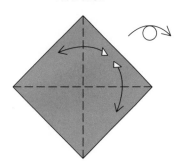

3.
Precrease the sheet in half both ways.

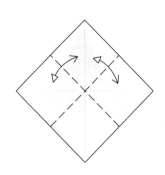

4.
Fold the bottom corner to the center on the guideline.

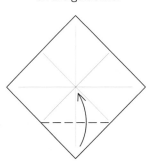

5.
Pull the dotted corners down.

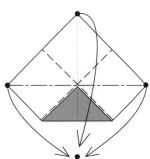

6.
Step 5 in progress.

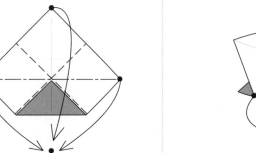

7.
Precrease the sides and the top corner to the center on the guidelines.

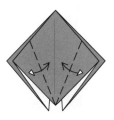

8.
Pull the flap up, allowing the sides to fold toward the center and flatten.

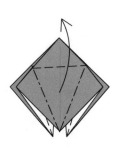

9.
Step 8 in progress.

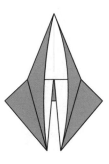

10.
Fold the flaps behind on the guidelines and turn the Giraffe over.

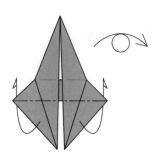

11.
Fold the flaps down on the guidelines

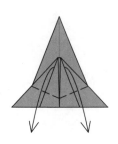

12.
Fold both flaps down on the guideline.

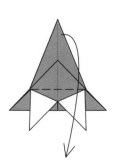

13.
Fold the top flap up on the indicated guideline.

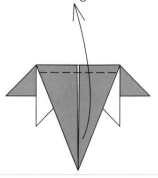

14.
Fold the Giraffe in half (right side over left) and rotate it an ⅛ turn.

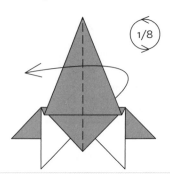

15.
Slightly open the front layer on the back of the neck. Reverse fold the neck into this layer on the indicated guidelines.

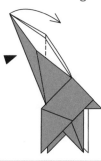

16.
Reverse fold the point to form the head.

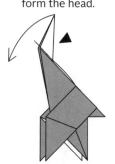

17.
Reverse fold the tip of the flap behind on the guideline.

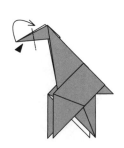

18.
Completed Giraffe.

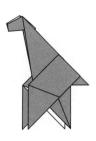

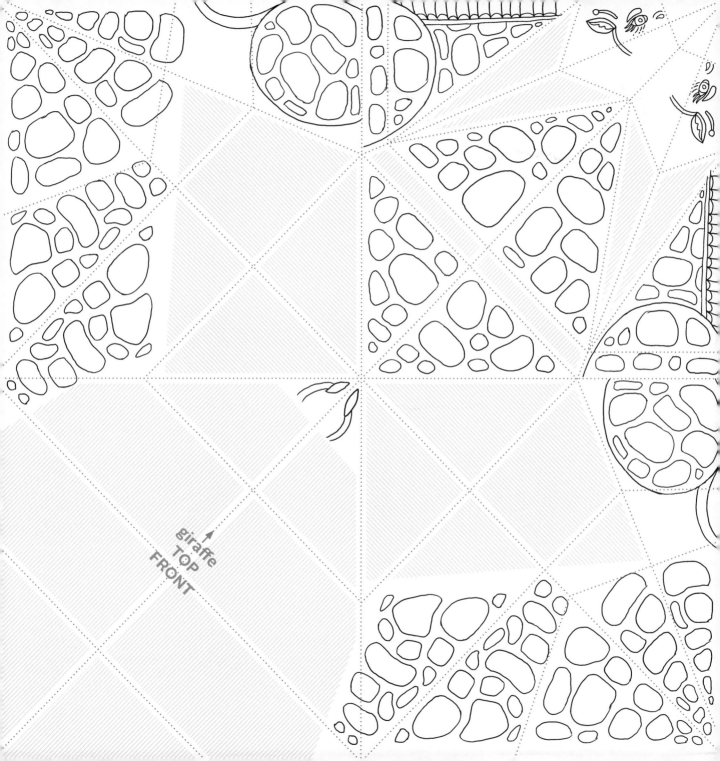

giraffe
TOP
FRONT

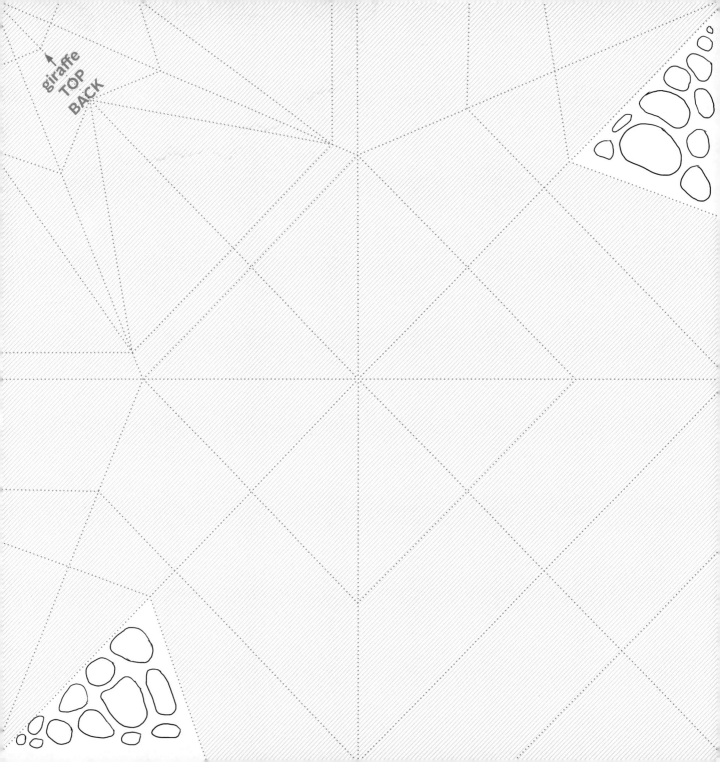

giraffe
TOP
BACK

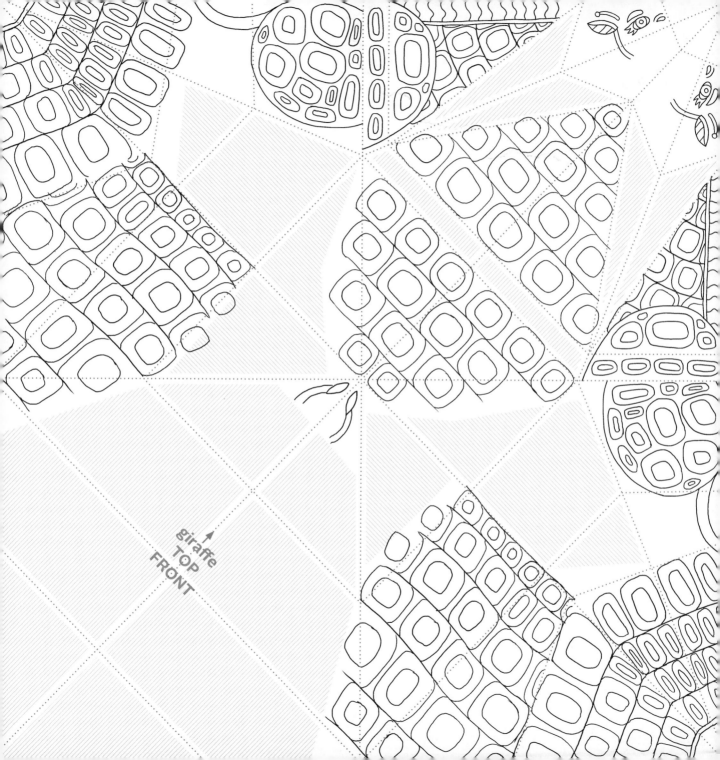

giraffe
TOP
FRONT

giraffe
TOP
BACK